MERRY
CHRISTMAS UNCLE
— 2019 —
RALEIGH, NC

MW00998597

ECU

PRESIDENT'S OFFICE

2010

RALEIGH, NC

CLIMBING
FITZ ROY
1968

Reflections on the Lost Photos of the Third Ascent

CLIMBING
FITZ ROY
1968

Reflections on the Lost Photos of the Third Ascent

Yvon Chouinard, Dick Dorworth, Chris Jones,
Lito Tejada-Flores, and Doug Tompkins

patagonia
BOOKS™

Contents

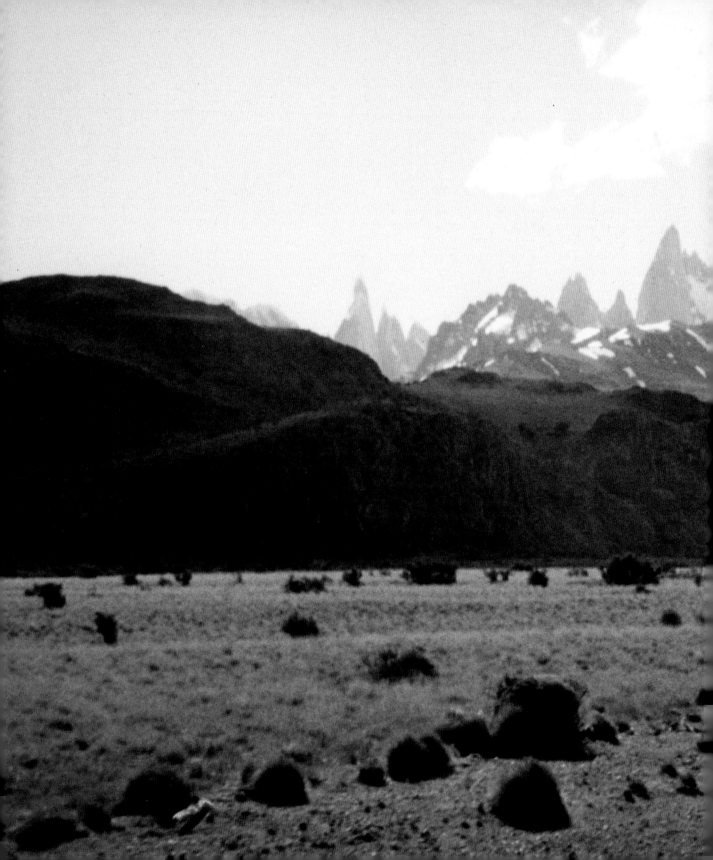

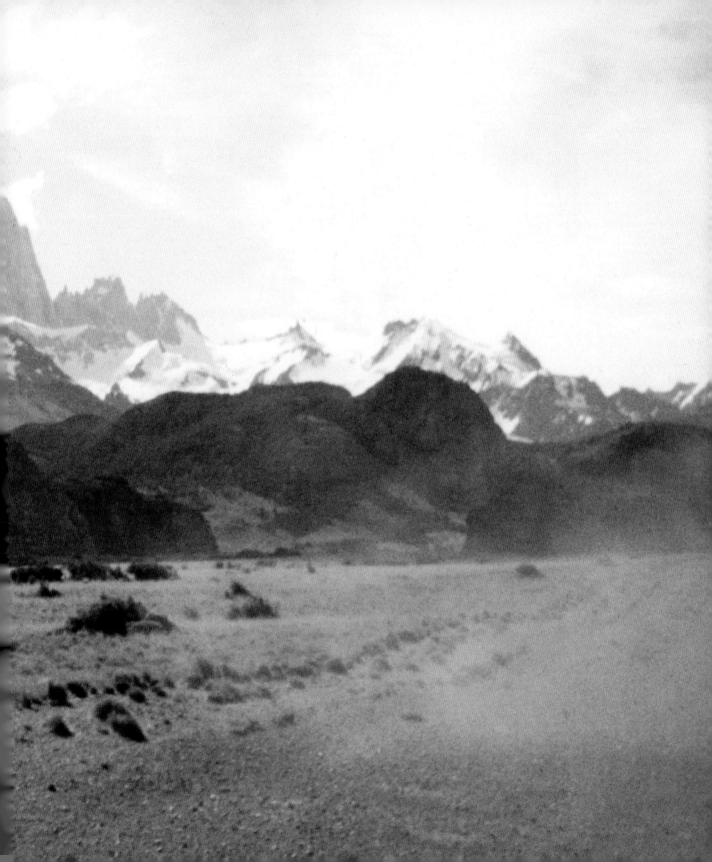

An Extraordinary Power

When I met the Funhogs in Lima, Peru, I was amazed that not one of them had a still camera. I had just finished a climb in the Cordillera Huayhuash, where each of my three companions had two Nikon 35 mm SLR cameras and a suite of lenses. While Paul Dix and Roger Hart were photojournalists eking out a living in South America, Dean Caldwell and I had aspirations, at the very least, of showing slides to local climbing clubs back home. These slide shows were part of the climbing ritual, even how you established your bona fides.

My own interest in photography was sparked in my early teens by the incandescent images in *Life* and *Paris Match* by photographers such as Henri Cartier-Bresson and Alfred Eisenstaedt. At age sixteen, I visited my relatives in the Netherlands and was mesmerized by the Leica 35 mm cameras in a store window. The camera used by my heroes! At that time, post-war Britain had draconian import duties on cameras; we could afford the camera, but the duty would be prohibitive. Still, I bought the one in the window, even though I had to smuggle it through customs. I can still feel the dread as I walked toward the customs agent, with what seemed an enormous and telltale shape in my trouser pocket. My mother, equally nervous, engaged the agent in some chitchat, and somehow we got through.

I loved that Leica IIIC; it was a beautiful object and had a silky smooth action. I spent hours in the murky light of the school darkroom, developing and then enlarging black-and-white film. In 1957, my boys' school staged an opera, *Circe,* written by the music teacher. I cannily talked my way into being the show photographer. Although I sold many dozens of prints, the pictures were rather flat. Of course, schoolboys in Grecian garb and garish makeup were not really attractive in the first place.

Climbing, however, was a more natural subject matter for me. I often toted the Leica along, though not always, for even such a small camera was hard to manage on difficult climbs. Once I moved to California, the work of local masters such as Ansel Adams and Edward Weston inspired me to take a photography class from Jack Welpott. Under his tutelage, San Francisco's decaying industrial buildings and the Big Sur coast became my subjects.

Returning to the Funhog saga, once we reached Santiago, Chile, we began to round up supplies. The list in my notebook said, "Film: Ektachrome; Kodak Plus K" (a black-and-white film). Then I'd written a note: "7 films for $28,"—about two shots a day for the trip! We used black-and-white film to create prints; color was too expensive. Furthermore, black and white was the medium of "serious" photographers.

For me the most telling pictures from Peru were of the Andean people. Paul Dix and Roger Hart had made stunning images, the beauty of the people shining through. But curiously, we did not photograph each other in the same way. It seems to me we were too inhibited to poke a lens at our pals, and they in turn were reluctant to pose—or in some cases

Previous spread: An early view of the Fitz Roy group from the main (dirt) road. Nothing prepared us for this sight of astonishing mountains rising out of dusty and dry plains. - CJ

even to sit still or look at the camera. We did not recognize that we were becoming actors on the alpine stage. Where are the insightful climbing portraits from America or even Europe from the 1960s and 1970s? Where was our Annie Leibovitz? I know now what we should have done, but out of trepidation we missed the "decisive moment."

Lower down the mountain I sometimes used my Pentax 35 mm SLR with its interchangeable lenses, but on the technical climbs it was too cumbersome. On difficult terrain, I much preferred the far smaller Rollei 35. With an excellent Tessar lens, the Rollei 35

slides—much of the fabric of my life—were all gone.

While I had not looked at the artifacts for years, their loss had a strange effect. I began to wonder whether I had really lived through all those experiences. Was I the person, the climber, that I believed I had been? Those events shaped who I was, and now they were receding into the distance. Fortunately, a 1998 phone call from my English climbing companion, Jerry Lovatt, pushed these doubts aside. He asked me to be the keynote speaker at an Alaska symposium to be staged by the Alpine Club in North Wales; I was legitimate after all! When I accepted the invita-

"WAS I THE PERSON, THE CLIMBER, THAT I BELIEVED I HAD BEEN? THOSE EVENTS SHAPED WHO I WAS, AND NOW THEY WERE RECEDING INTO THE DISTANCE."

was compact enough to slip into your pocket; it was always at hand and ready to go.

Once home in January 1969, I went through the usual process of removing the Kodak-provided cardboard slide mounts, washing the slides, and then laboriously mounting them between glass with an adhesive edge tape. They were then stored in boxes with slots and a space for captions. But after a small flurry of shows, the slide containers slowly gathered dust over the years. Moved from home to home, they remained undisturbed.

On July 31, 1996, our home was destroyed in a wildfire. With the surrounding roads closed, air tankers dropping fire retardant and firefighters fully engaged, my wife, Sharon, and I reached our home via a dirt track on the back of a neighbor's motorbike. To our relief, our wheaten terrier Sadie was wandering around in the parking area—the firefighters had discovered her lying by the door as they entered the house and revived her with oxygen. Henry, our other wheaten, and our cats, Rufous and Zoe, all perished. It was a terrible blow. Negatives, prints, notebooks,

tion, I did not have one slide for such a talk. Former partners helped me out with duplicate slides of my lost photos. But none of the Funhogs I contacted could find their copies. Somehow, those images of an unforgettable climb had drifted away.

Several years later, and quite by chance, Dick Dorworth came up with the missing photos. In a real sense, he returned these events to me, to us. When I think of my life, it is often through the photographs of those times.

I can still remember the prints in photo albums and the framed ones that hung on my walls. Those original pictures are long gone, yet I can still see them in my mind's eye, and through those reimagined images, the equally long-gone events come back to life. Photographs, for me, have an extraordinary power.

Chris Jones
Glen Ellen, California

Perseverance, Patience, and a Bit of Luck

Early on the morning of December 20, 1998, I was in the tiny studio apartment I rented in Ketchum, Idaho, drinking coffee and getting ready to go skiing. The phone rang. On the other end of the line was a British accent asking, "Where were you on this day thirty years ago?"

Caught off guard, my mind drew a blank. "I don't know," I replied.

"Ahhhhhh, does the name Fitz Roy ring a bell?"

Of course it did, and it all came back into focus. We had climbed Fitz Roy thirty years earlier. "Is this Chris?"

And of course it was, Chris Jones, the expat Brit who lives in California, the fine climbing historian, friend, and Funhog companion and still photographer on the grand journey to climb Fitz Roy, checking in to commemorate our great adventure together.

We seldom see each other, but it is always a pleasure, and an education, to talk with Chris. We had a good conversation that morning, but we didn't mention photos or photography, an avoidance that, in retrospect, is revealing. I never see a photo of Fitz Roy without thinking of my friends on the trip; all the still photos were taken by Chris with his tiny Rollei 35 camera.

Six years later *Alpinist Magazine* featured Fitz Roy in its winter issue and, naturally, I read it cover to cover. One of the photo captions included this: "Chris Jones, author of *Climbing in North America*, lost most of his archives to a fire that burned down his house."

Wow! Bummer! I hadn't heard that Chris's house had burned down and he lost his enormous collection of climbing photos and manuscripts, including the Fitz Roy photos. I thought of my own archives, stored at Alpine Storage Lockers in Shoshone, Idaho, fifty miles south of Ketchum where rent is less expensive than in the ski-resort town where I live. Some fifteen trunks, boxes, and bags filled with priceless (to me, if not the world at large) memorabilia: hundreds of personal photos ranging from grandparents to grandchildren; skiing and skiers from all over the world dating from the 1940s to the present; climbing in North and South America (including Alaska and Canada), Europe, and Asia; rock concerts with Dylan, Baez, the Grateful Dead, and others; many dozens of manuscripts including a first draft of *Night Driving* (the memoir I published in 2007) in longhand; thousands of pages of journals, scrapbooks, posters, books, and many other historical, personal mementos. I neither wanted to imagine, nor find out, how devastated I would be if my locker of treasures burned down.

Without hesitation, I phoned Chris in California. His wife, Sharon, answered and informed me that Chris was out. After introductions, as Sharon and I had not met, the conversation went something like this:

"I just read that your house burned down and all the Fitz Roy photos were lost. Is that true?"

"Yes, and Chris is heartbroken."

"Well, I have them." Silence.

"What?"

"I have them. The Fitz Roy photos." Silence.

"I have duplicates from years ago. I still have them all."

"Oh my God." A couple of hours later Chris phoned. His excitement vibrated through the phone.

"Is it true?"

"Yes."

"Wow!" After eight years of photographic death, there was rebirth.

I explained that the dupes were in my trunks of treasures in a storage locker, and we agreed that I would get them and have them scanned and would send them to Chris. It was a very happy phone conversation.

Then, of course, complications arose. The storage locker is the size of a small closet and I am a collector, not an archivist. Somewhere in the closet were the duplicate slides and, as I figured out over several months, not all the slides were in the same trunk.

I promised Chris I'd get the dupes, and every time I went to Shoshone I would dig through a trunk or two. At first I found just one batch of Fitz Roy photos, but I knew there were more. It took several months of sporadic digging before I found them all, had them digitized, and sent to Chris. I fear it was very frustrating for Chris, and I apologize. Like the climb itself, finding the Fitz Roy photos required patience, perseverance, and a bit of luck.

Dick Dorworth
Ketchum, Idaho

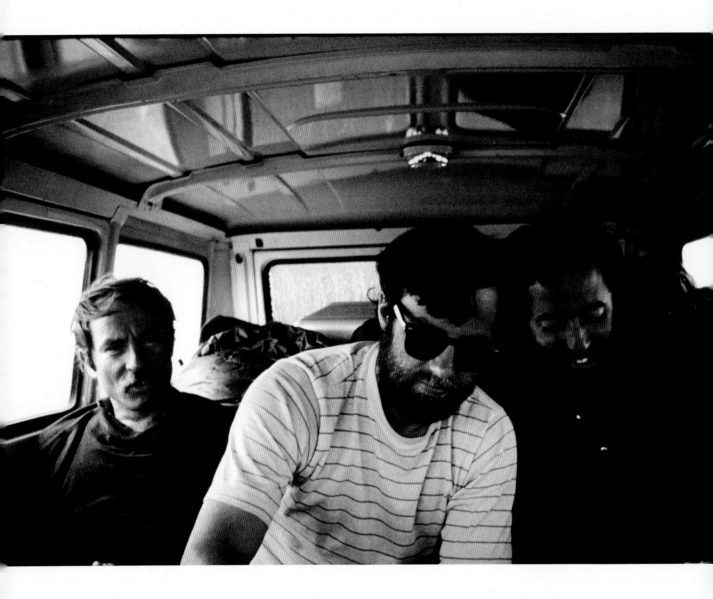

Yvon Chouinard, Dick Dorworth, and Lito Tejada-Flores (left to right) in the Ford Econoline, somewhere in Patagonia. The polished aluminum case at the rear contains the Nagra sound recording equipment. By this time we had off-loaded the surfboards and skis that had started out on the journey. - CJ

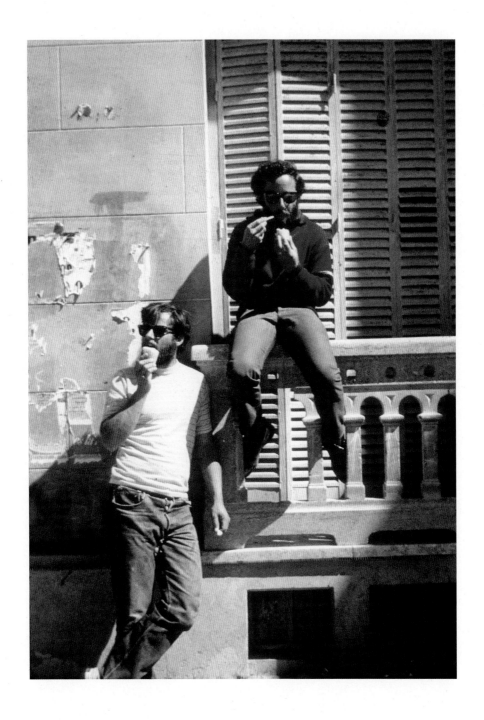

Dick (left) and Lito eat ice cream in Santiago, Chile. Our Ford Econoline had broken down, so Doug Tompkins and Yvon were slaving away in the street, rebuilding the engine. - CJ

The soldiers were there, they said, to defend the border because any moment Chilean tanks could come across the Southern Patagonian Ice Field and attack Argentina. At the time Argentina had more generals than the United States! - YC

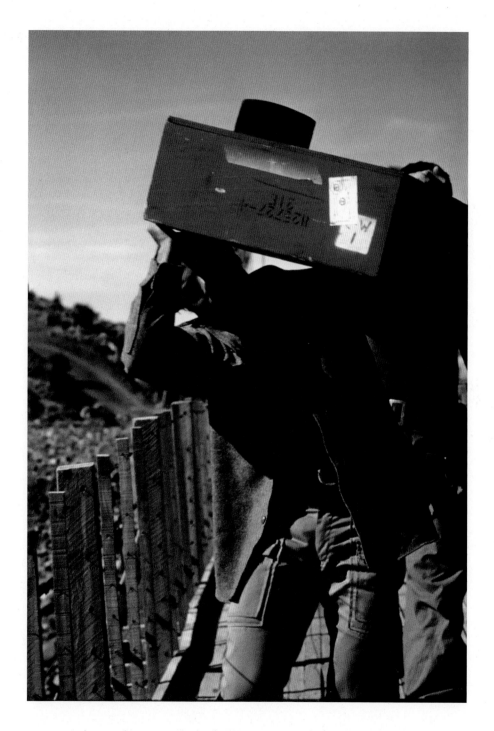

At the time, there was no bridge for cars going across the Río de las Vueltas. - YC

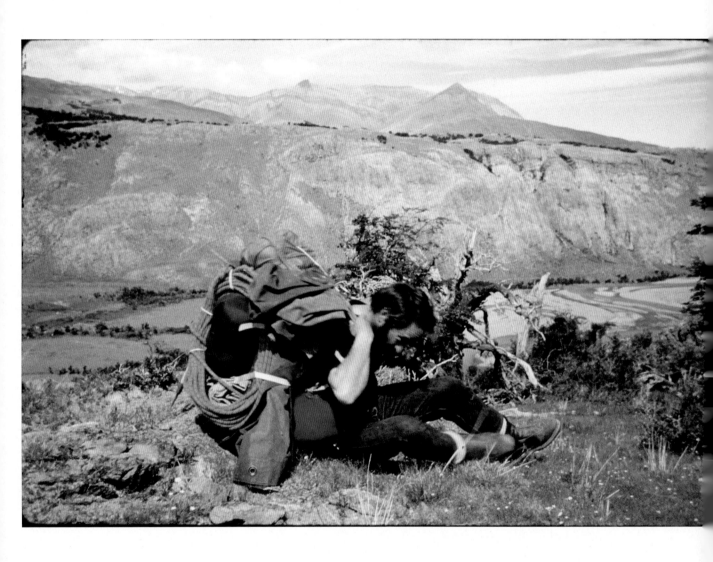

Yvon struggles to his feet with a crazy load to carry up to our base camp. He is wearing French Le Phoque boots, which had an ingenious rubber flap to cover the lacing system. They were good boots for the period. - CJ

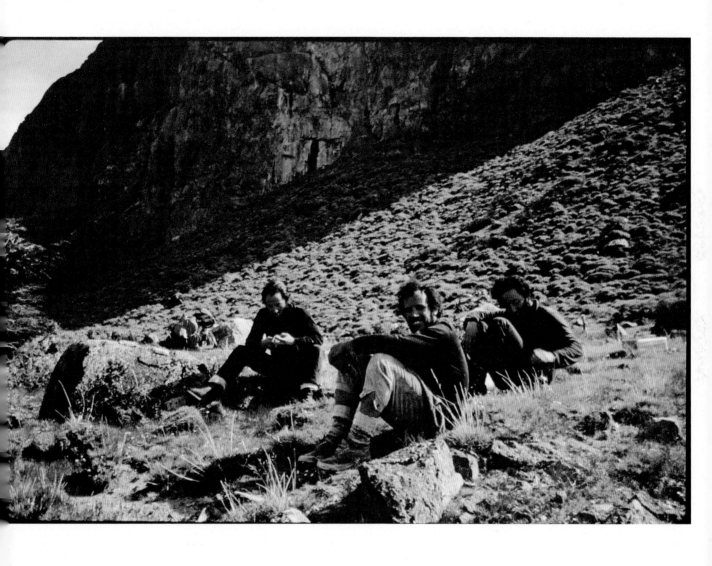

Yvon, Doug, and Lito (left to right) take a lunch break from ferrying loads to the first ice cave. - CJ

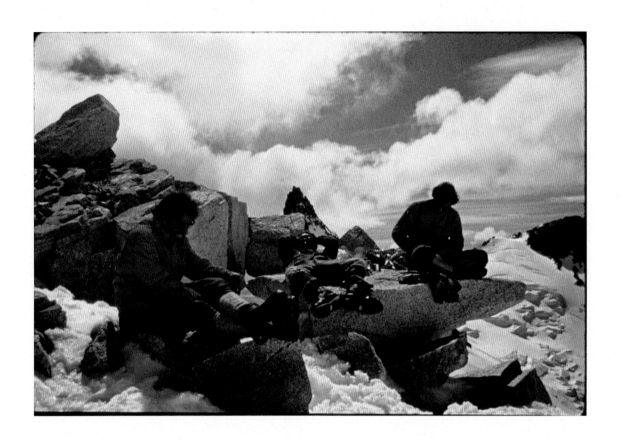

Doug, Yvon, and Dick (left to right) lounge on rocks near the first ice cave. - CJ

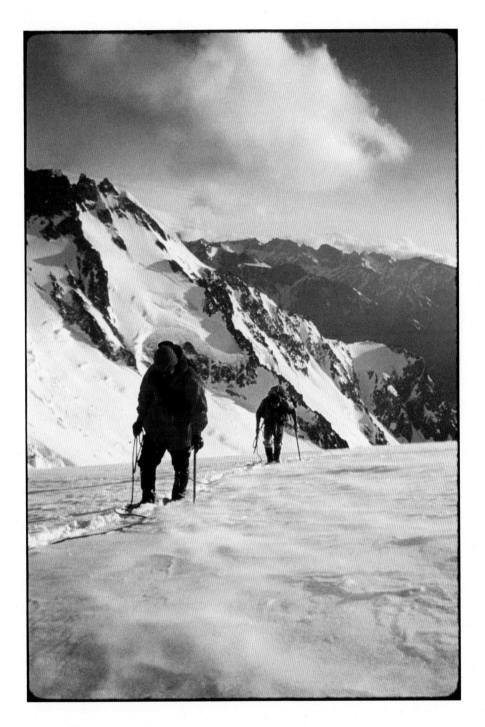

Dick (in front) and Yvon carry loads across the Piedras Blancas Glacier, up towards the Italian Col. - CJ

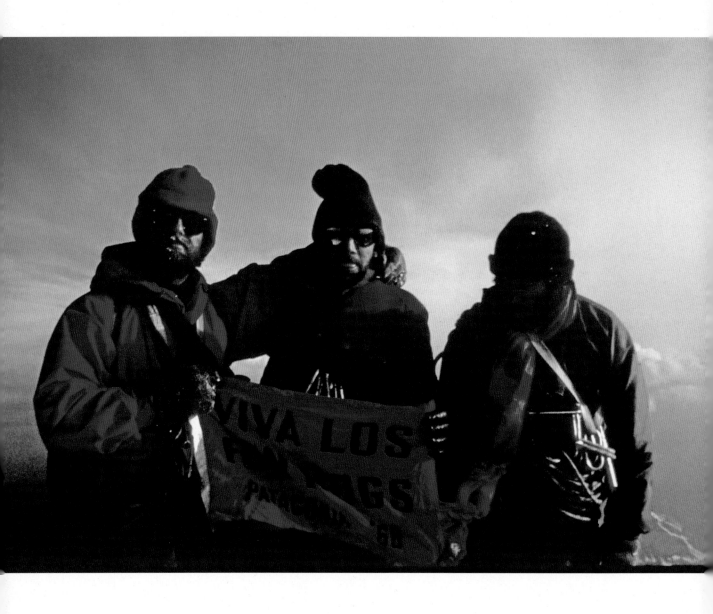

December 20, 1968: 8 p.m.. Funhogs, from left, Dick, Doug, and Yvon on the summit of Fitz Roy. Our Funhog banner was loosely translated for the locals as "Sporting Porks." - YC

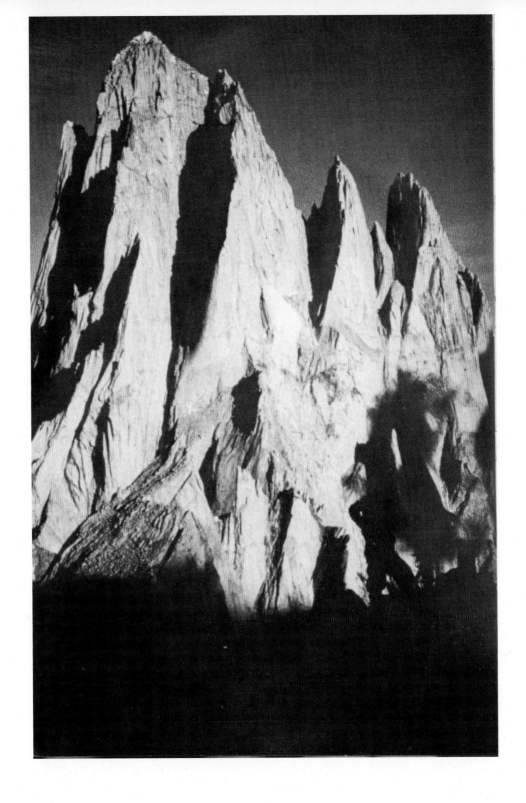

Fitz Roy, 1968

Douglas R. Tompkins

How did five able and intelligent California Funhogs get involved in the Expedition Game? Shouldn't we have known? Sure. It happened by accident really; we hadn't planned it that way. It all began one sunny morning in Ventura, California. I was visiting Yvon Chouinard to do a little surfing near his beach-side home. It was already hot that morning and the talk soon turned to colder regions. An Argentine climber, José Luis Fonrouge, had been in California and shown us slides of Patagonia. One needs only to see a single mediocre color slide of the Fitz Roy massif to want to go there. Yvon mentioned having read the book of the first ascent of Fitz Roy by the French in 1952 and added that in his autobiography Lionel Terray had called it his hardest and finest climb. Plans were made that morning. Who else? How? When? We could work it out. . . .

Finally it was decided to leave in mid-July. We could travel slowly and get to the mountain in time for Patagonian spring, hoping to catch a possible spell of good weather before the famous summer winds. Besides, we wanted to change the tactics of the Expedition Game and an appropriate physical and psychological build-up had to be planned. Finger bells and chanting "Om" would not be enough. We could replace such passive conditioning with surfing, skiing and a steady sampling of international cuisine. We would approach our mountain by land, driving from California, surfing on the west coast of Central and South America, skiing for a month in Chile and then, on to Patagonia. In general, we were going to "hog fun" as much as we could for six months. Plans were piled on plans, fantasy on fantasy; by nightfall we had concocted the trip of trips. We were like boys who sneak into an ice-cream shop at night

PLATE 1 *Photo by José Luis Fonrouge*

FITZ ROY from the west. The Funhog Route rises from the col up the right skyline.

to make themselves a gigantic sundae or banana split; it's all free and the soda jockeys are always so stingy with the syrups. To protect ourselves from the risk of overindulgent guilt we decided to make a film of the whole trip and pass it off as a business venture.

Dick Dorworth, a veteran ski racer and one-time holder of the world speed record on skis, had joined the group; and Chris Jones, in Peru on another expedition at the time, wrote us that he could join the Funhogs in Lima. Lito Tejada-Flores who had just finished working on a film of El Capitan in Yosemite was delighted to come as photographer. The Funhogs were ready, Lito and I left San Francisco with a van full of climbing, surfing, skiing and cinema equipment on July 12th. We picked up Yvon and Dick in Ventura and made for the Mexican border in sweltering weather. The *First California Funhog Expedition to Patagonia* was underway.

At Bariloche, we were generously taken care of by new-found friends at Club Andino Bariloche. Expedition food was bought and last-minute equipment preparations made. Bariloche is the Jackson Hole of Argentina with lakes, mountains and plains very much like Wyoming. It offers skiing, climbing, fishing, and superior steak dinners. We began to adopt the same strict steak diet boxers do, anticipating lean times ahead.

Four days later, after numerous flat tires and a gruesome 20 M.P.H. pace, we were rewarded at sundown with our first view of the Fitz Roy massif. We weren't prepared for it. 16,500 miles of driving, three and a half months on the march wasn't enough! Had we somehow made a mistake? We hadn't known it would be like this! So big, so beautiful! So scary! This was a gigantic Chamonix, a gargantuan Bugaboos. Huge was our only impression and we were sixty miles across the plain. To the south of the range, at the end of Lago Viedma, spilling into this lake, more than sixty miles long, was a Himalayan-sized glacier! Those first few minutes were perhaps the most mentally debilitating of the whole trip. A strong fear, a sense of losing confidence came over me, similar to the way you feel when coming to Yosemite to climb a big route on El Cap; you drive in and suddenly see the wall. I'm going up there, you ask? Wait a minute. Should I? Can I? Our hearts rose and sank. This was quickly covered up by nervous laughter, jokes, talk, anything to get the mind off the central problem—fear??? Our talk turned to smaller peaks, lesser objectives. However, intimidated as we were, we all knew that Fitz Roy was the undisputed king of the massif. Even the sharp, steep pinnacle of Cerro Torre sat in its shadow. Fitz Roy was a peak *to* climb, the terrible Torre one *to have* climbed. The script, however, was written

the moment we first saw the range, our film not withstanding. It had been a long march; the ice cream and syrups were spilling over the edge of the dish; it was time to find the spoon. I believe we all felt that way. The objective now, having made the greatest sundae which that shop would ever see, was to eat it all, to finish everything in order to justify our escapade. We could see it was going to be a test, a long meal. Had we made the sundae *too* large?

As we drove the last forty miles to the river where we would leave our car and transfer our equipment and food to an Argentine Army truck to be taken the final fifteen miles, the peaks never seemed to grow larger. Our spirits soared, the weather was flawless and we slept under a huge moon. The next morning a most knowledgeable army lieutenant, Silveira, took us into the National Park at the edge of the Río Fitz Roy. The following day, breaking a tradition of Patagonian inefficiency, we set out, with military horses hauling our gear, for Base Camp in the woods by the confluence of two small rivers, the Ríos Blanco and Chorillos. Our objective: Fitz Roy, of course.

For the next eight days we had reasonable weather, though not good enough for high up on the mountain. We were approaching the mountain from the east as the French had in 1952; this is perhaps the most difficult approach, for it demands expedition tactics with a string of camps. We were backing into the expedition business very nicely. We had wanted a taste of glaciers, couloirs, ice caves—the Total Alpine Experience! (Remember, we are now five Funhogs inside the soda fountain late at night and are heaping on chocolate syrup, whipped cream and *all!*)

Those eight good days of weather carried us with all our equipment for the summit as far as the couloir leading to the Italian Pass. We had by this time bypassed neatly the great east buttress of Fitz Roy that rises vertically out of the *Piedras Blancas* Glacier for 5700 feet to Fitz Roy's summit. Virtually a Half Dome stacked on El Cap! This climb, we were to discover, belongs to the next generation or to someone ahead of his time. Its foreshortening from the glacier was to keep us speculating until ten days later when we saw it in awesome profile from the col or *Silla* beneath the French route. The eastern side of the Fitz Roy cirque of granite peaks (comprising St. Exupéry, Fitz Roy, Mermoz and Guillaumet) is generally protected from the strong winds that blow from the west, across the Continental Icecap. The winds are made out there on the icecap; the storms from the Pacific, only fifty miles away, bring the snow. This icecap lies behind all the true stories of terrible Patagonia weather. We found feet of deep snow, dropped on the leeward side of the range,

to be the rule. Eight days of bad weather forced us back to Base Camp and sobered us to the fact that the good weather was not about to last indefinitely.

We reascended during the first break in the weather and spent two days filming and climbing the couloir leading to the *Brecha de los Italianos* or Italian Pass. We established our second ice cave, called the Cado* Cave, at the base of Fitz Roy's southeast buttress, about 500 yards west of the bottom of the French route. On the final day of that four-day good weather spell, Yvon and I began an investigation of the French route, only to be turned back on the preliminary ice slope when Yvon, our ice specialist, inadvertently chopped a step in his knee; we had to hospitalize him during an entire week in the Cado Cave. The same afternoon, in search of alternatives, Lito and I crossed the small glacier that drops away into the Torre canyon, and reached for the first time a small col between the unclimbed *Pointe du Cinéaste* (or *Aguja de la Silla* on official maps). From there we could see a practical route, more reasonable than that of the French in that one could see approaching weather from it; also it seemed much less iced-over.

We returned to the ice cave with good news; but just as this was a spirit-lifter, so was the ensuing 15-day bad-weather period spent in the Cado Cave a downer! Fifteen days in an ice cave without books or cards can wear heavy on the minds of even the most stable Funhogs. Yet we became strangely secure; our future was assured as long as we could hear the wind roaring outside. Finally, however, as the M & P's (mental and physical decay) set in and our food diminished, we were forced out into the wind on a semi-lull afternoon and retreated in the storm to our first ice cave. The next day we went down to Base Camp.

We had been in the area five weeks and had completely exhausted our food. The script had been written but the wind was blowing away our lines; we couldn't act out the final scene. It was there waiting, a new route, the third ascent of one of the most inaccessible summits of the Americas. We knew it was within our grasp, but as we drove out in our van the 100 odd miles to the nearest western-frontier-style trading post in the lonely pampas in search of more provisions, Lito and I also knew that we were really not much further along than the first day we had seen the peaks. We had not seen more than four continuous clear days, and only a couple that would have been suitable for the summit; right between two seasons, the weather appeared worse than ever. . . .

* Anything that is screwed up (origin: The Psychedelic Avo*cado* Man).

Lito and I managed to buy and then tote 150 pounds of new supplies up to our Base Camp where Yvon had kept himself busy baking honey-tasting bread in an oven the French had thoughtfully left us. Chris was drying clothes and sleeping bags as best he could. Dick was looking for his mind, lost somewhere in that 15 days of solid ice-cave living. We were now up to 25 straight days of storm when, unbelievably, the weather broke. Yvon, Chris and I had taken an overnight hike down to the historic Madsen ranch in the *Río las Vueltas* valley, but in one strenuous day we made it all the way to the first cave to join our companions with all our new supplies. The next day saw us back in the Cado Cave with six days of food. No luck! Six days of solid storm later, after many elimination rounds of the 1968 Patagonian Invitational *Truco** Championships, we were once again in the couloir going down for more food. A familiar routine! However we climbed back up to the upper cave that same afternoon, this time with almost three weeks of food—we were there to stay!

You can't second guess the weather on Fitz Roy; the very next day dawned almost perfectly clear. My enthusiasm encouraged a bit of trickery on my companions as I had set the alarm an hour ahead to help with the delays in getting breakfast and leaving the cave. We were away at 2:30 and did the first snow pitches rapidly despite the dark, arriving at the base of the rocks on our route at five A.M. We climbed mixed free and aid pitches until noon, gaining altitude rapidly. Yvon and I had reconnoitered the route to a point level with the *Pointe du Cinéaste* several days before during a false start in inclement weather, and we thought the climbing difficulties might ease off above us in a couple of pitches. Our need for encouragement had left us open to deception, but we found new walls above each crest. Yvon and I led alternately while Lito filmed on Jümars; Dick, only in his first year of climbing, followed fourth, and Chris cleaned the ropes. We climbed extremely fast for a rope of five, the back-up team doing a great job, never letting the leaders wait, always keeping the party moving. As for the climbing, it was delightful; we hadn't yet seen granite as nice as this, rough surfaced with fantastic cracks. Fingerless wool gloves were the order of the day—our finest piece of gear!

By two P.M. we reached a notch overlooking the Super Couloir. The evaporation clouds formed over the Continental Icecap had been set into motion by the ceaseless wind, and they shot into the Super Couloir where up-drafts sent them firing on over the summit. The weather was bitterly cold and the route appeared blocked by a ridge of snow-plastered

* Argentine card game played with tarot-type cards.

gendarmes. A hard lead took us around the first tower. Four hours and four towers later, we reached the final snow and boulder slope. I had to rappel one pitch and do a short 20-foot section before I could unrope. My enthusiasm to see if there would be any more technical difficulties caused me to set off ahead while the others finished their pitches. I climbed third-class until I could see we had it, then I walked out to the lip above the top of the Super Couloir and saw my companions appear and disappear in the clouds below. This couloir, the second ascent route (*A.A.J.,* 1966, 15:1, pp. 75-80), is the most practical and forthright route yet done on the mountain. It calls for no expedition tactics as it rises directly from the Base Camp on a glacier 6000 feet below. It took two days originally and is a big mountain route in every aspect. As I stopped to wait for the others (so we could go together to the summit), I knew that we were going to finish the banana split that evening. It was seven P.M. and we were almost there. Shortly, one by one came Yvon, Lito, Dick then Chris. We had Lito, our hard-working photographer, go first and reach the summit ahead of us as a gesture of appreciation for his thankless job of filming, and we joined him for our chance to savor that cherry on the whipped cream topping. It was eight P.M., and the long rays of sun gave us a view beyond compare. Cerro Torre was below us, enveloped periodically by clouds; it looked just as unclimbable from up there; the great ice-mushrooms, just as cold, just as frightening. The Aiguille Poincenot, over a thousand feet below, looked friendlier and very climbable.

After twenty minutes on the summit, we began the descent. The rising wind poured clouds in from all sides. Nervous about being caught out in a Patagonian bomber, it was not until two A.M., that, exhausted and having at last found a ledge, we cut short our pitch-black rappels and bivouacked. It was a miserable bivouac, but very short, with incredible cold and wind. By dawn we were ready for any kind of movement and resumed the descent in ferocious winds; rappel ropes refused to fall; the noise of the wind in the *Col de la Silla* cracked like a whip at a circus lion. We arrived back at the Cado Cave at eleven A.M., worn out and cold, and after a victory *flan** dropped off to sleep until late afternoon. The lines of the script had been spoken correctly, we had our film; Lito had managed to shoot 1000 feet on the climb the day before, summit and all. We were proud of ourselves.

In the following days we cleaned out our camps and found ourselves free men again, with no excuses for anyone, especially none for ourselves.

* Custard, the *only* high-mountain pudding.

The sudden change in our fortunes was too much for us. We found ourselves watching our food allowance when we had an immense surplus; we still awoke at three A.M. to check the weather. The old dreams of frustration persisted. Slowly our minds adjusted to our success as we hauled our gear out to the van. Flowers, animals, singing birds, green grass and full streams greeted our return to the valley. Summer had arrived. Prospects of a lamb *asado* (barbecue) spurred us along under our absurd loads. It was Christmas day and what were we doing? Carrying 100-pound packs! We looked back at "Old Fitz," as we now called it, being on familiar and equal terms. We looked back, not as artists for we weren't artists, just five tired Californian Funhogs finishing up the trip of trips, licking the dish with a smile from ear to ear, and mustaches full of ice cream saying one to the other—"I believe we've done it! I do believe we have!"

Summary of Statistics.

AREA: Patagonian Andes, Argentina.

ASCENT: Fitz Roy, 11,289 feet, third ascent by a new route, the Southwest Ridge; Summit reached by whole party on December 20, 1968 in a 30-hour round-trip climb from Camp II after a 60-day struggle; NCCS VI, F9, A2, good ice climbing, weather unstable, wind ferocious.

PERSONNEL: Yvon Chouinard, Rafael Tejada-Flores, Richard Dorworth, Christopher A. G. Jones, Douglas R. Tompkins.

ML

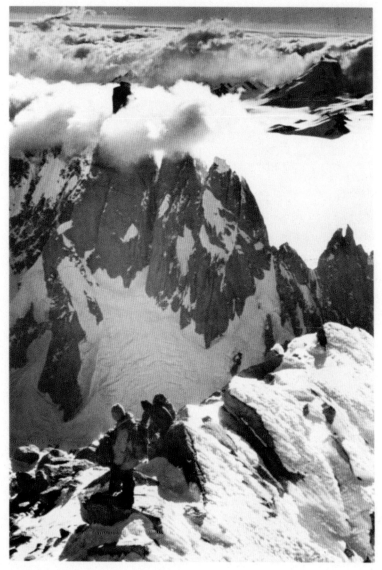

PLATE 2 *Photo by Christopher A. G. Jones*

**Within ten meters of the summit of FITZ ROY. CERRO TORRE
pierces the clouds in front of the Continental Icecap.**

This article originally appeared in the 1969 *American Alpine Journal,*
published by the American Alpine Club. americanalpineclub.org

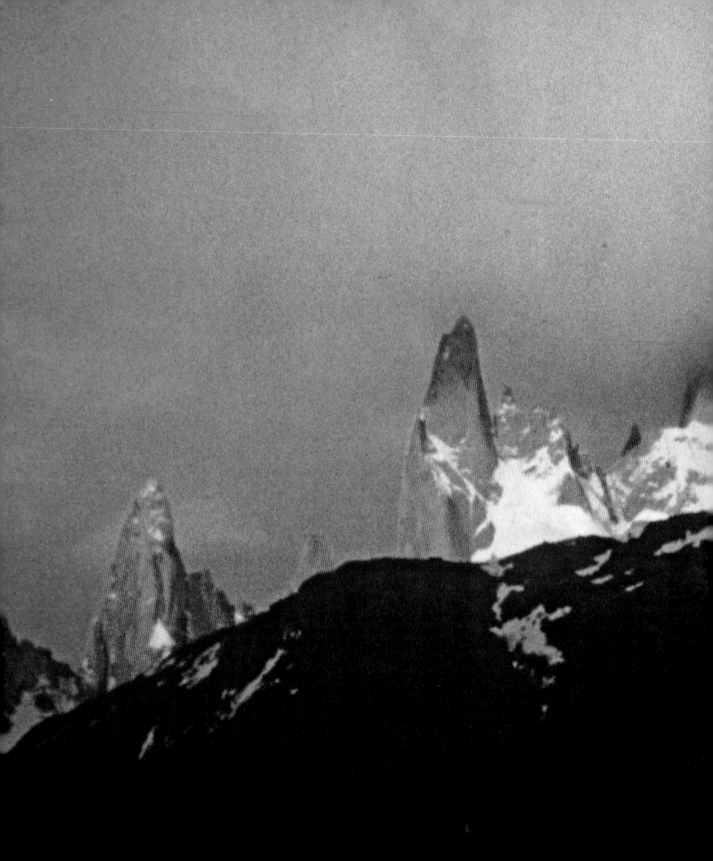

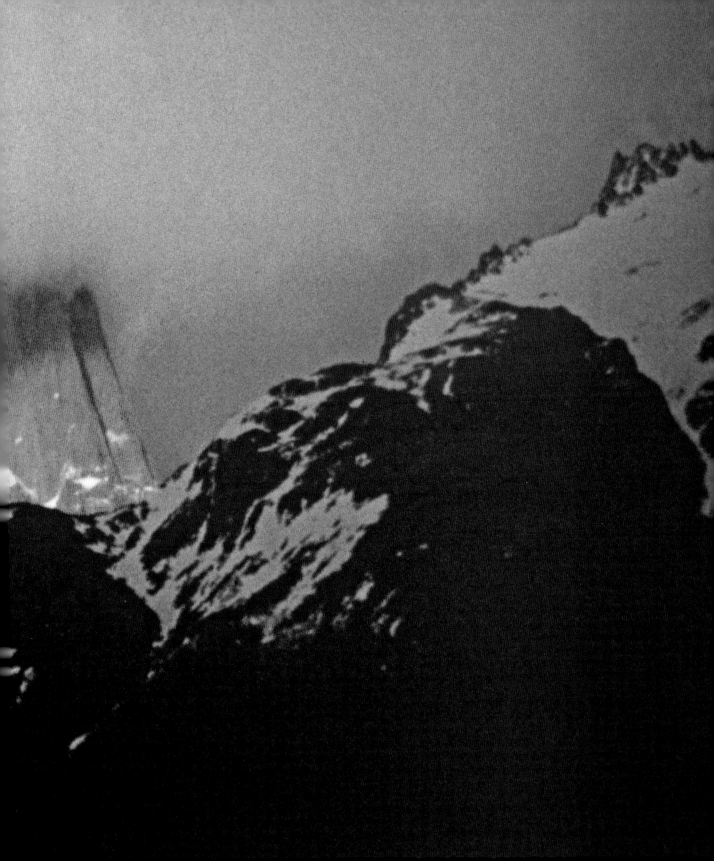

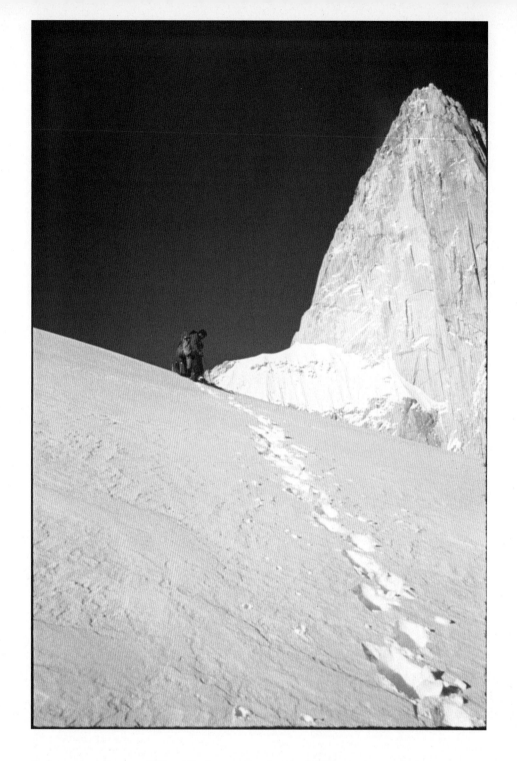

Previous spread: Poincenot (left) and Fitz Roy enveloped in clouds. - CJ
Making the route up to the base of Fitz Roy. The 1952 French first ascent route lies slightly to the right of the rock buttress. - CJ

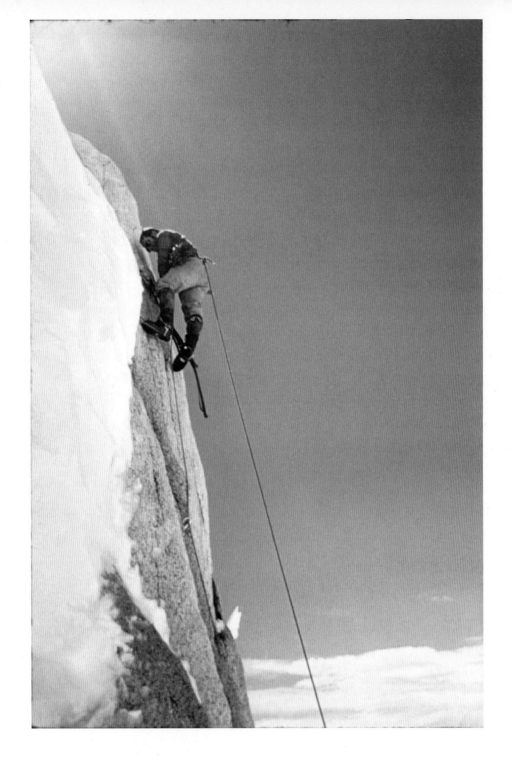

To reach the couloir leading to the Italian Col, we crossed the bergschrund to its right. Here Yvon leads off the glacier. His hardware rack is predominantly pitons, but includes early versions of climbing nuts or chocks. - CJ

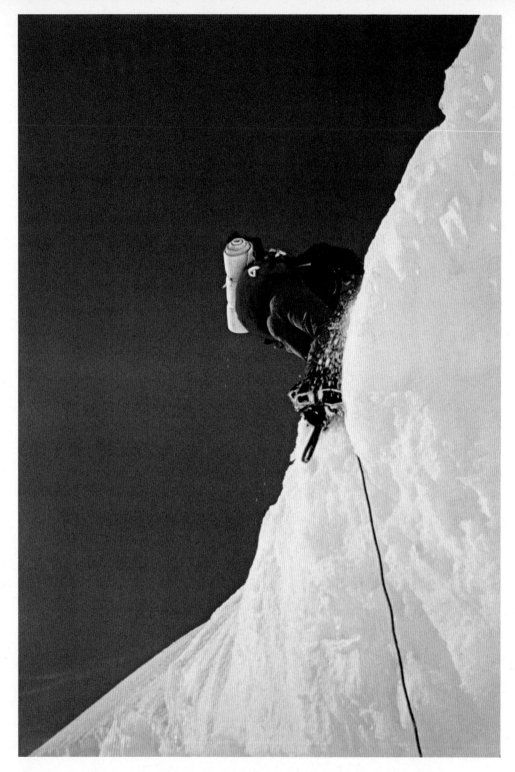

Lito jumars over the bergschrund on a fixed rope. He is using an early version of rigid crampons introduced by Chouinard Equipment. - CJ

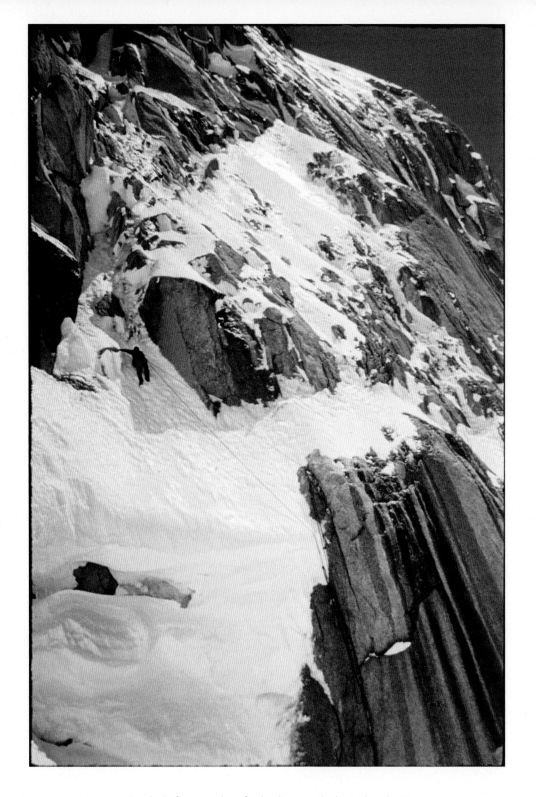

Yvon looks for an anchor after leading over the bergschrund. - CJ

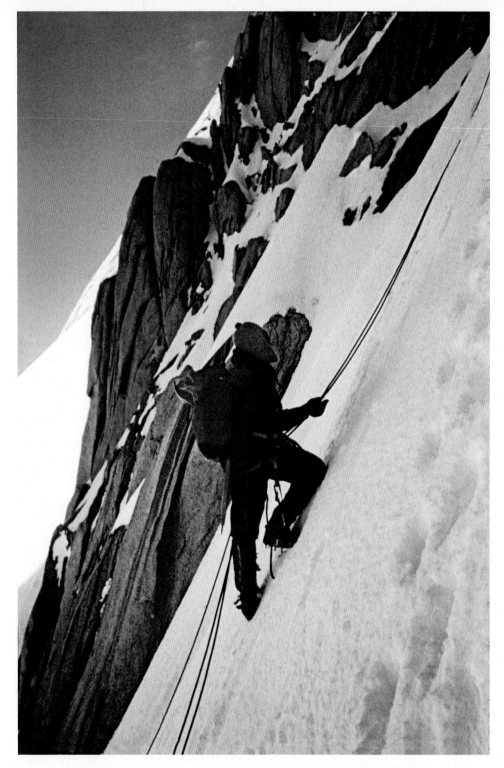

Dick rappels down from the Italian Col. We made this trip several times while stocking the second ice cave and eventually retreated when our food ran out. - CJ

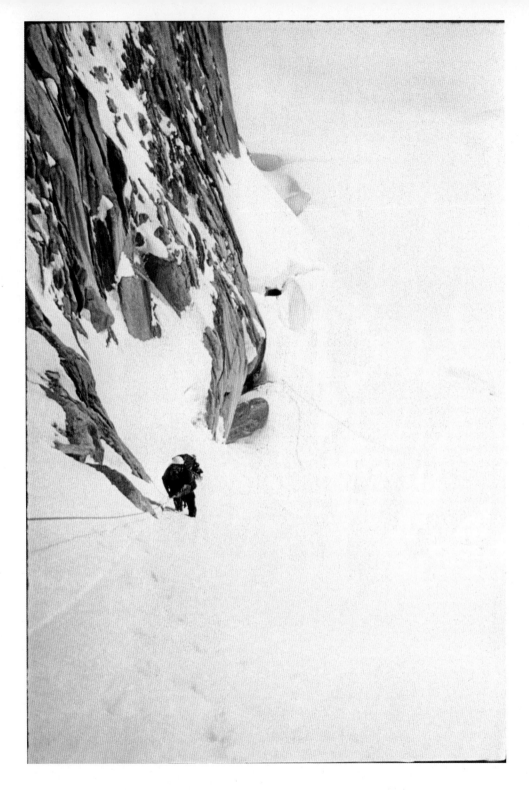

Chris Jones jumars up ropes above the bergschrund. - CJ

The view down towards the lower flanks of the east face of
Fitz Roy from near the couloir leading to the Italian Col. - CJ

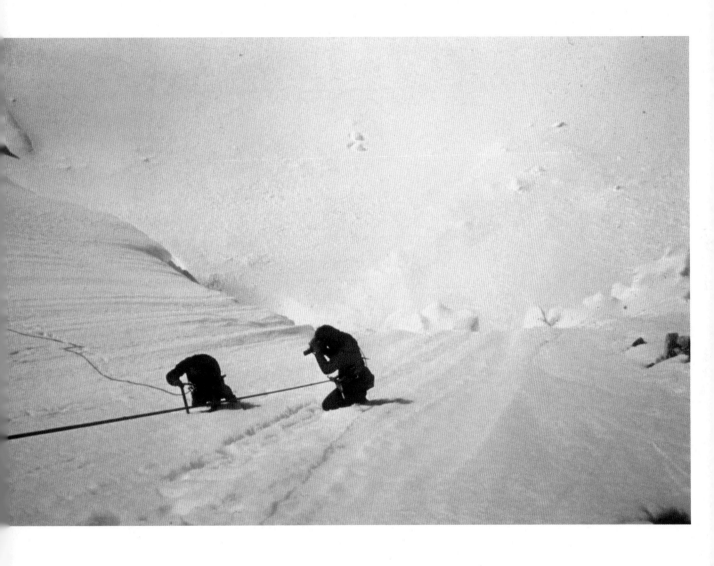

Lito films above the bergschrund at the base of Fitz Roy. - CJ

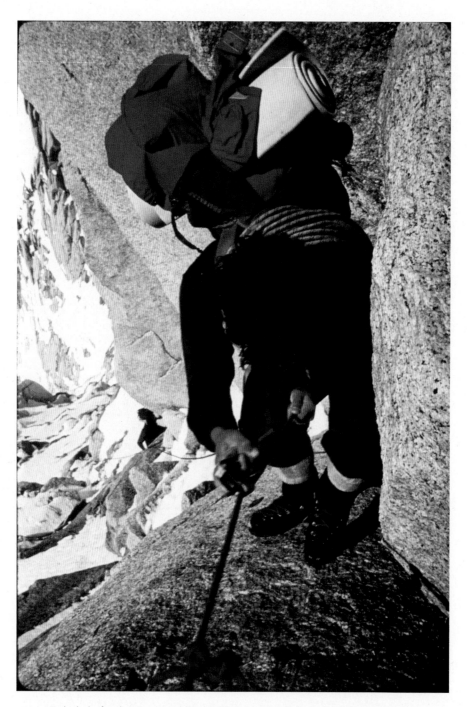

Dick climbs fixed ropes up to the Italian Col; another climber is on the ropes below.
This was Dick's first real mountain climb and he performed astonishingly well. - CJ

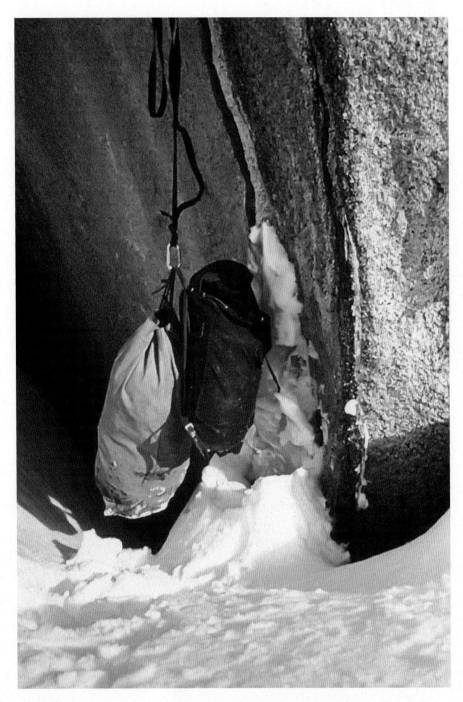

Gear cached at the foot of the Italian Col. The gear hangs from a piton to keep it clear of the snow. Note the canvas climber's pack, and what looks to be a US Postal Service mailbag. - CJ

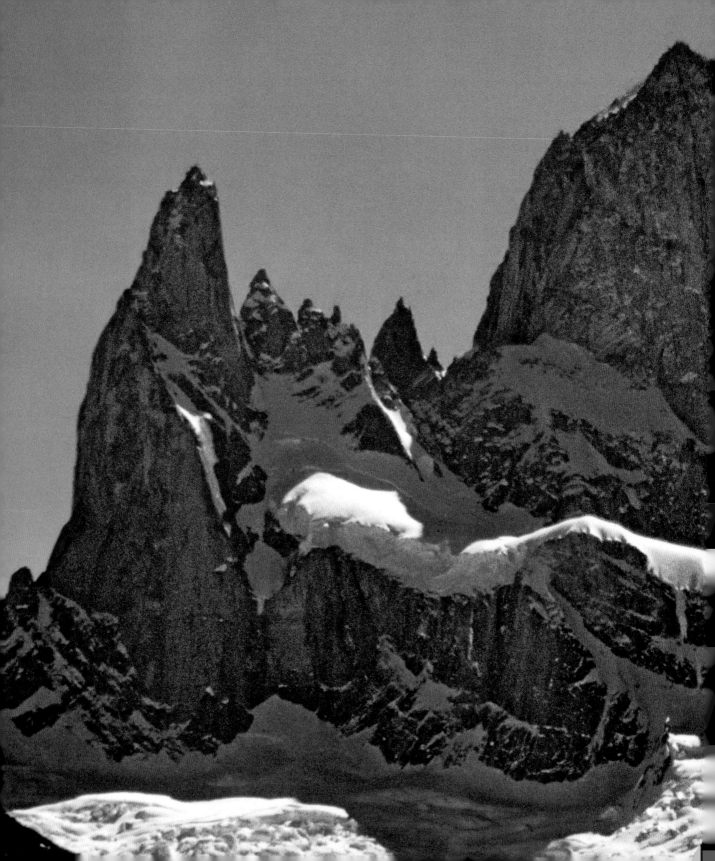

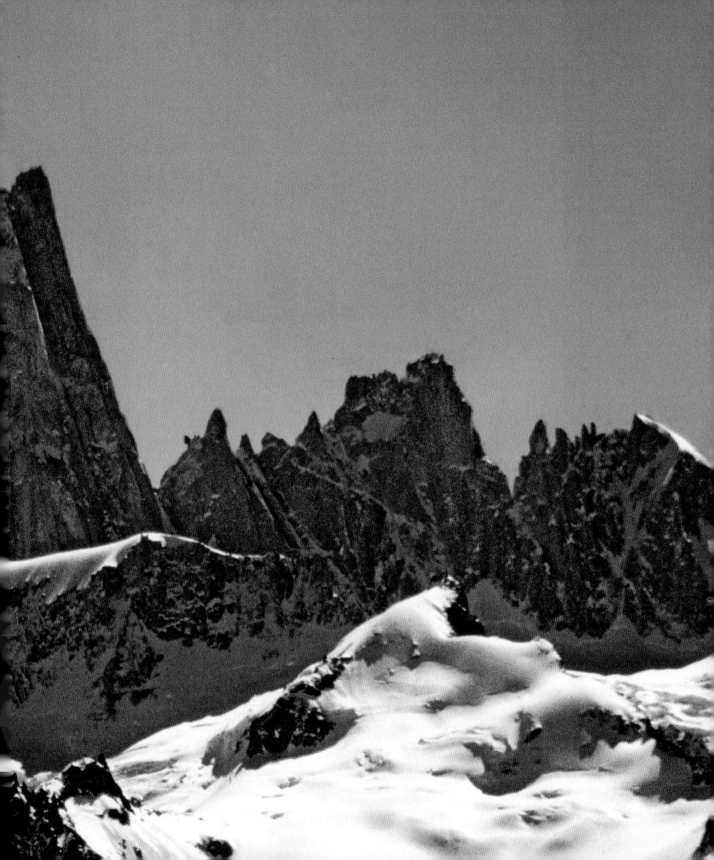

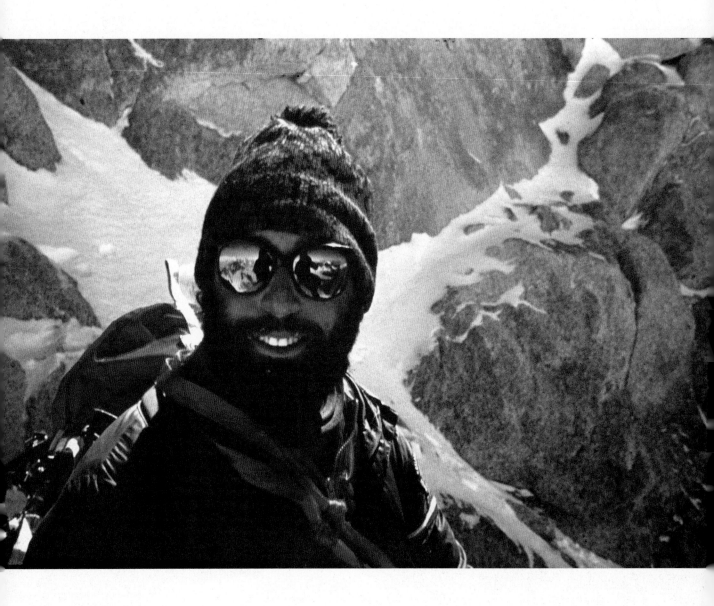

Previous spread: The view from near the Italian Col. Cerro Torre on the right, and the flank of Poincenot on the left. - CJ
Filmmaker Lito near the Italian Col. He is wearing then-fashionable ski gear: Vuarnet glasses, a ski hat, and a French ski school jacket. - CJ

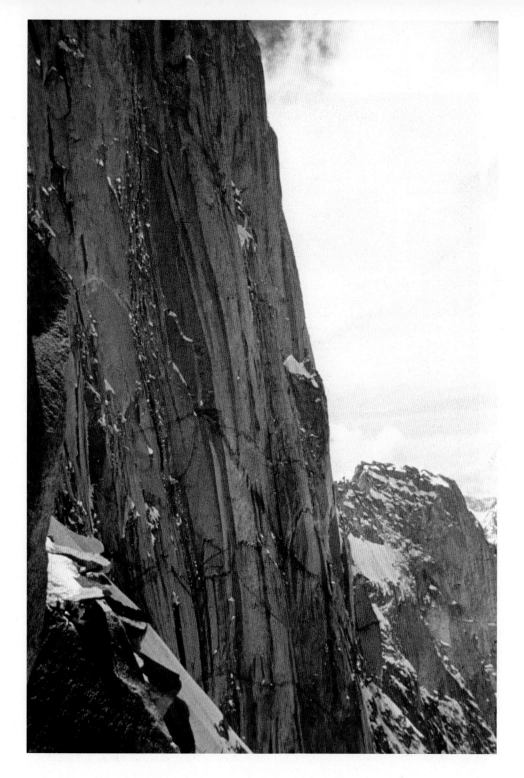

East face of Fitz Roy. Originally we had thought of attempting this face,
but it was apparent that it was beyond our resources. - CJ

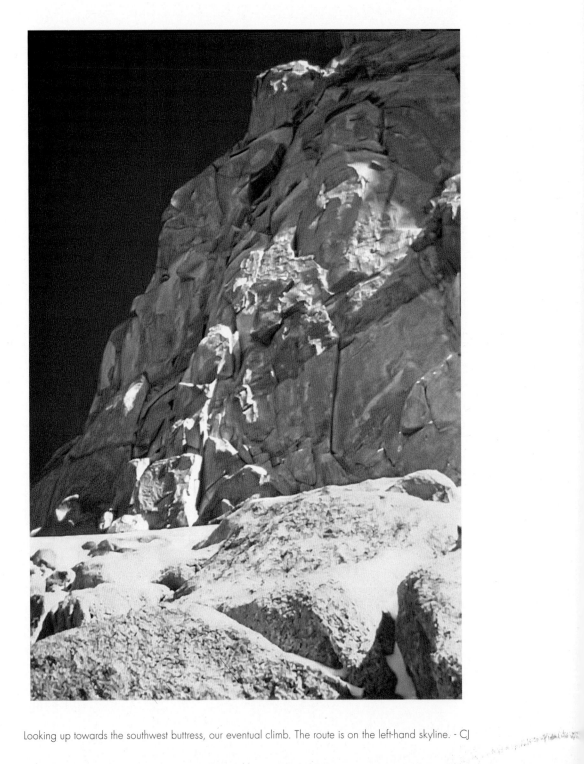

Looking up towards the southwest buttress, our eventual climb. The route is on the left-hand skyline. - CJ

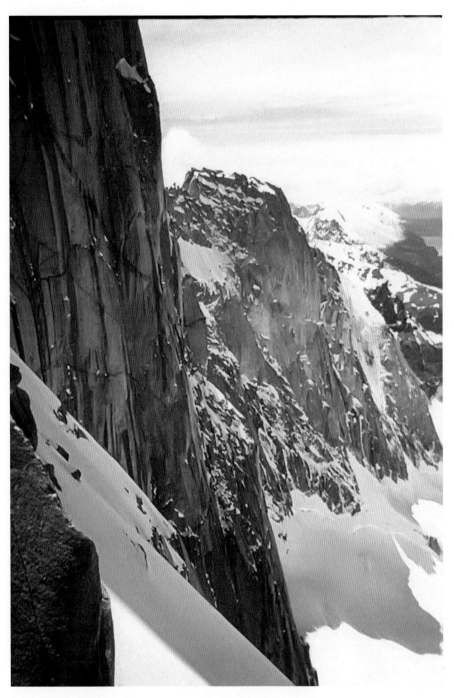

A French team, led by Bernard Amy, had attempted this face in early 1968.
In a bold effort, on a very technical route, they climbed some 500 meters. - CJ

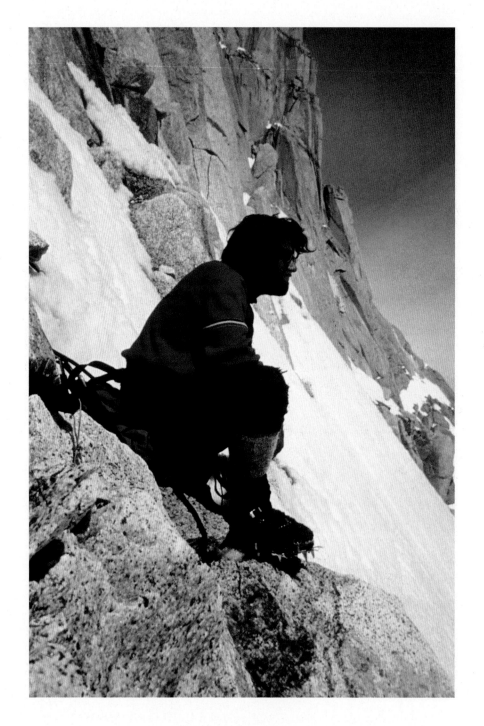

Dick takes a break. - CJ

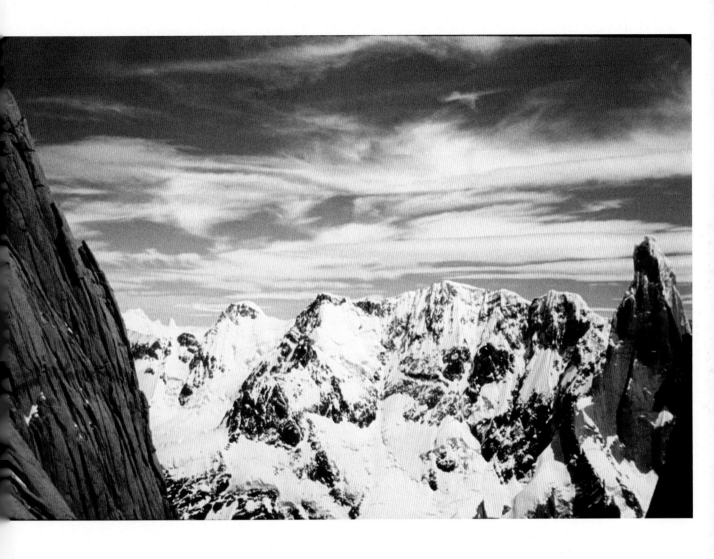

The Fitz Roy group. Our route roughly follows the left-hand skyline of Fitz Roy. The Aguja de la Silla is the low summit just to the left of Fitz Roy, and the col giving access to the California Route is visible. - CJ

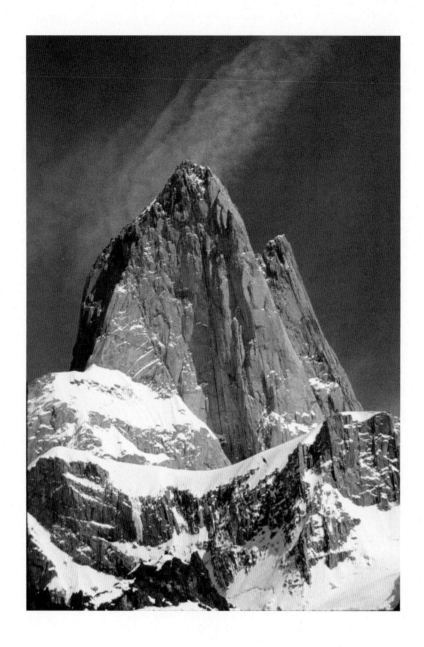

Our second ice cave was in the snow and ice slopes at the base of the ridge delineated by sun and shadow on the left. The French 1952 route lies to the right of this ridge. Our route closely follows the left-hand skyline ridge. - CJ

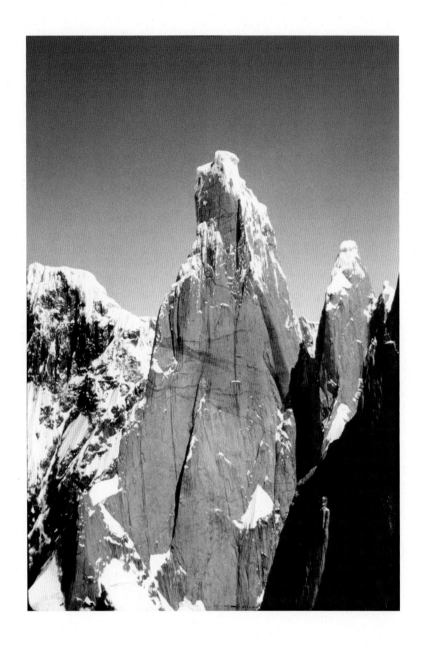

The enigmatic Cerro Torre, seen from the Italian Col. The enigma related to the claimed 1959 ascent by Cesare Maestri and Toni Egger. Their claimed route was in the shadows, up to the notch to the right of the peak, then up rock and ice to the peak. Subsequently, it was definitively shown that they had, in fact, made little progress towards the summit. - CJ

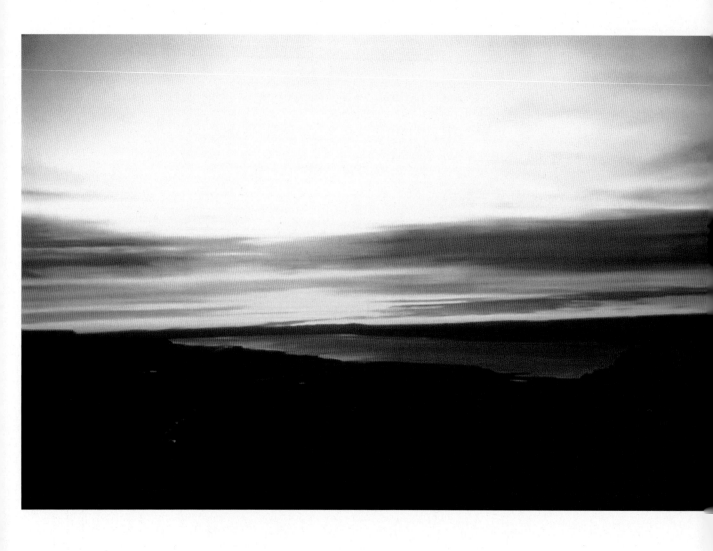

Sunrise over Lago Viedma, as seen after leaving the first ice cave to carry loads up the mountain. The clouds tell of bad weather brewing. - CJ

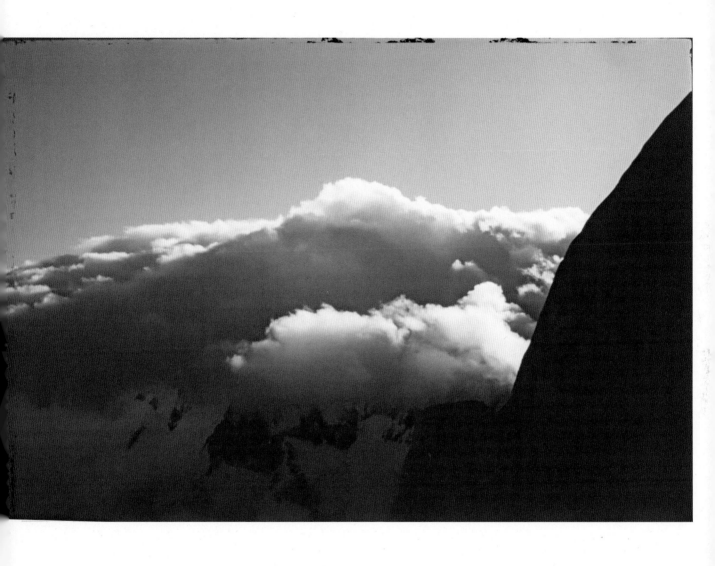

The roar of the wind is not unlike being under a 747 on takeoff. - YC

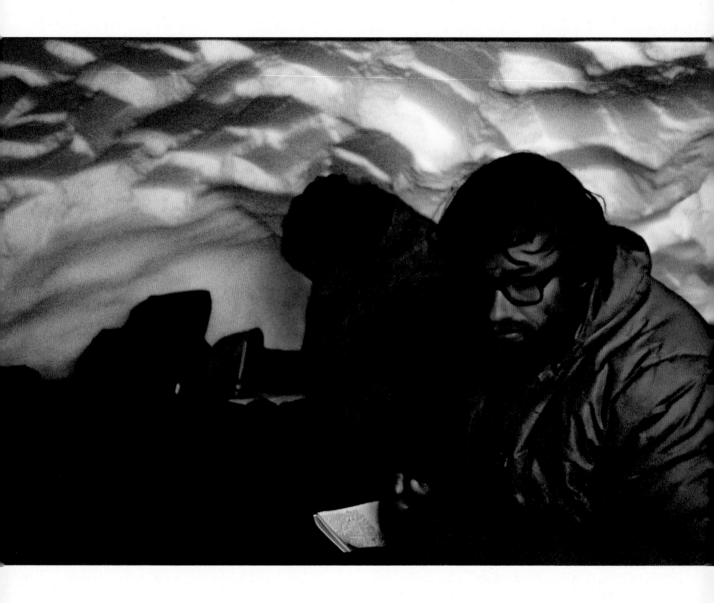

We spent a total of thirty-one days in ice caves. - YC

Viva Los Funhogs
Dick Dorworth

It was an epic journey, a wild and historic climb, an unusual adventure, a formative experience. In the context of the era and the lives we were living, the 1968 Funhog trip from California to Patagonia and the climb of Fitz Roy was a natural, even logical, step on the endless road of self-awareness and consciousness.

The climb, the trip, and the films—*Fitz Roy*, which Funhog Lito Tejada-Flores made, and the longer *Mountain of Storms,* which was made with Lito's footage and distributed by Patagonia—are, in certain circles and for good reason, relatively well known. The films are a fine depiction of the Funhogs in action, but understanding the social and cultural context from which they emerged is helpful to an appreciation of the significance of them, as well as the trip, the climb, the people involved, and their later paths in life.

Our route up Fitz Roy, now staidly known as the California Route, we originally called the Funhog route. We were of the 1960s generation in America, all in our twenties and inherently, purposefully, counter to the mainstream culture. "Cool" was giving way to "turn on, tune in, and drop out." The Beatles, Bob Dylan, Janis Joplin, the Grateful Dead, Jefferson Airplane, and Joan Baez played the music we wanted to hear.

With us as with many others of that generation, internal reflection was more important than external appearance; personal growth took precedence over material acquisition. And honesty, realization, and discernment were a lot more interesting and real than the kind of 1960s thinking that put half a million American troops in Vietnam, assassinated John F. Kennedy, Bob Kennedy, and Martin Luther King, Jr., and allowed Ronald Reagan to opine that if you've seen one redwood, you've seen them all.

It was 1968, an iconic year in American culture that focused the forces of the decade into indelible images, sounds, experiences, and struggles too well known to require listing here. The counterculture's vision of hope and change was wildly creative and idealistic, and it would be some years before we recognized that the members of the counterculture as well as their dreams had been lost into the mainstream and were barely visible apart from it. A few more years passed before it became apparent that some of those people and their values and dreams of a better world had not been lost, forgotten, or destroyed. Some of those people, as well as their values, were working (and continue to work) from within the mainstream. As our Funhog brother Yvon wrote in 2012 in *The Responsible Company*, "Most fundamental changes start at the margins and move toward the center." The question is whether the change reaches the center and affects the whole or gets lost in platitudes and inaction along the way.

Like the journey to Patagonia and the Fitz Roy climb, reaching the center and affecting the whole is the only path to freedom for a Funhog. Every life has the same end, so it is the journey of that life, not its

destination, that matters. Freedom, self determination and personal growth are found in the present moment of every mile, every breath, every move of each climb, trip and relationship. Freedom is not found in a future goal, though it might be discovered along the path to that goal. That path, like climbing, recognizes that hope, change, and wild idealism require patience, persistence in the face of difficulties, and an awareness that resolution is its own reward.

It's more interesting and fun to honor the reality that no two redwoods are the same, and that if you've seen one redwood . . . you've seen one redwood. We are sustained by each redwood truly seen, and we evolve by understanding and being inspired by

I wrote in my book *Night Driving,*

I found myself the steady driver on the grave-yard shift. I drove a lot of those 18,000 miles [sic] in the dark with all or most of the others asleep. Since we were passing through the borders of several of the most militaristic, suspicious, backward countries of the world, with jail and justice reputations bad enough to make us want not to get involved, we agreed beforehand to travel in a manner so as to make Mr. Clean seem, by comparison, the dirtiest, skunkiest, smelliest, most suspect traveling salesman ever to be caught crawling out of your thirteen-year-old daughter's bedroom window at dawn. And so we

"WE WERE OF THE 1960S GENERATION IN AMERICA, ALL IN OUR TWENTIES AND INHERENTLY, PURPOSEFULLY, COUNTER TO THE MAINSTREAM CULTURE. "COOL" WAS GIVING WAY TO "TURN ON, TUNE IN, AND DROP OUT."

the differences between each tree, person, culture, mountain range, and creature of the earth. The Funhogs of 1968 were on the road of realizing in each present moment the truism of the iconic John Muir's observation: "When we try to pick out anything by itself, we find it hitched to everything else in the universe." If you've seen one redwood, you're connected to them all.

Five years before our journey Ken Kesey and his Merry Pranksters had driven the psychedelic painted bus "Furthur" across the country. Tom Wolfe's book *The Electric Kool-Aid Acid Test,* which immortalized that trip, became required reading. Kesey in 1963 was somewhat insulated by a more tolerant society and laws against unreasonable search and seizure while driving across America in a psychedelic bus advertising counterculture values, but we could not rely on such an emancipated reception by the military sentries at the borders of Central and South American nations.

did, with me unbelievably accomplishing some of the longest, hardest night driving of my career, completely straight. I had some astonishing (to me) adventures and lessons and experiences and, you know, revelations on the nighttime roads of South America during that trip.

On the morning of July 16—Yvon Chouinard, Doug Tompkins, Lito Tejada Flores and I—gathered in the utilitarian yard of Chouinard Equipment in Ventura, California, to begin a six-month, 16,000-mile journey in a 1965 Ford Econoline van to Patagonia. It was the first time I met Yvon. As the member of the group with the least climbing experience, I was not expected to participate in the actual Fitz Roy climb except to carry a few loads up the lower glaciers. When Doug first proposed the idea of the journey I accepted that, but as the trip progressed and I became more connected to both the intention of the trip and my comrades as friends, I did not. The counterculture not only connects all

things, it tends to be all-inclusive, 100 percent as opposed to, for instance, 1 percent and 99 percent.

I wound up at Chouinard Equipment that morning through a friendship with Doug Tompkins. We had met a year and a half earlier through skiing when I was a graduate student in English at the University of Nevada and Doug was running the North Face in San Francisco. The business was at the forefront of what Jack Kerouac termed "the rucksack revolution," which eventually changed the outdoor retailer and manufacturing industry of America from the margins of society to the center. Doug had been a companion on a drive from Whitefish, Montana, to Reno, Nevada, after a day skiing in Sun Valley, Idaho. That drive included an all-nighter filled with conversations about life, its choices, and its passions. I made some decisions during and after that drive that altered the course of my life and described them in *Night Driving*:

> *I heard for the first time on that trip the words "Chouinard" and "carabineer," both of which were to become interwoven with my life within a couple of years. When we arrived in Reno, just before a February dawn, tired and wired, and ready to come down in the bed I had been away from for a week. . . . I went to see the head of the University of Nevada English Department and told him there was no way I would ever again endure another deathly dull graduate seminar, a morbid sentence inflicted on people so lazy and unimaginative as to have nothing better to do than attend graduate school, a punishment specializing in creating a previously unknown and unnecessary "problem" (trace the development of R.W. Emerson's writing, as seen in the history of American literature, beginning with Jonathan Edwards) and then talking that "problem" into the ground, nay, clear through the crust into the bowels of the earth and on out the other side, China, where the people are more intelligible*

> *than those experts on the English language who haunt graduate seminars. I retired from that world a few hours after that trip, and I never felt better, as if the fatigue of 10,000 years on the front lines had suddenly been removed.*

Having purposely sabotaged my half-hearted mainstream career path to become a professor, I detoured for the summer of 1967 to work and live in the San Francisco Bay Area. It was the summer that the Beatles released their album Sgt. Pepper's Lonely Hearts Club Band and 30,000 people attended the Gathering of the Tribes in San Francisco's Golden Gate Park a prelude to that fine city's Summer of Love. Afterwards, I scurried back to the mountains where I belonged and could most comfortably pursue internal reflection and personal growth.

That winter I taught skiing at Squaw Valley. Among my fellow ski instructors was the inimitable, brilliant, irrepressible Lito Tejada-Flores, a long-time friend and climbing companion of Tompkins. Lito and I quickly became friends and spent many enjoyable hours skiing together and discussing any and everything that we found interesting and fun, including skiing. Doug joined us during breaks from San Francisco; it was a very good winter of skiing and sorting through the options of life. Sometime that winter Doug began talking about a plan to spend the summer driving the length of South America with a couple of friends—including Lito as well as that guy Chouinard who made carabineers—to climb some peak in Patagonia. Lito would make a film along the lines of *The Endless Summer*, and though he had never made a film before, Lito was brilliant and could figure it out. "And would you like to join us?"

The answer "Yes," was the right one, despite having never climbed, not having much money, and a couple of personal matters, including a gravely ill mother, that would surely encourage those of a different mentality to stay close to home. When I discussed Mom's

prognosis with her doctor and told him about the trip, he told me she might live ten minutes or ten years, and there was nothing I could do for her. He advised me to go to South America. (I was able to show Mom the film Lito made of the trip before she died. She loved it.)

The answer was "Yes," and I knew it, but I didn't say so for awhile. Meanwhile, a couple of synchronistic people and events popped up along my road to commitment.

English Annie was wintering in Squaw. She knew Lito and a few other friends, and became part of our circle. Annie was waiting for her Scottish fiancé to return from a climb in South America. His name was Dougal Haston and he failed to get up something called Cerro Torre. When Dougal came to Squaw to join Annie, I didn't know a Cerro from a Torre or that he was one of the great alpine climbers of the twentieth century, but we met and formed a fast and fine friendship rooted in several late night philosophical discussions washed down with lots of alcohol.

Dougal was a great drinking companion and, while usually a man of few words, a superior conversationalist once he chose to open up. One night he asked, "Wud ya like ta learn ta climb?" The answer "Yes," was the right one and given not because I cared about learning to climb, but because I enjoyed Dougal. For the next few days he dragged me up some crags around Tahoe and Truckee. When Dougal returned with Annie to Europe he left me with a basic climbing education and I was hooked. From the first day on the Truckee Boulder, climbing filled that missing piece of my life that had been empty since the end of ski racing three years earlier.

Synchronism is never singular. To the intellect alone, the synchronistic is nothing more than meaningful coincidence, but by that stage of the 1960s the counterculture was familiar with more than peace and

love, and sex, drugs, and rock and roll. It was Carl Jung who wrote:

Synchronicity is no more baffling or mysterious than the discontinuities of physics. It is only the ingrained belief in the sovereign power of causality that creates intellectual difficulties and makes it appear unthinkable that causeless events exist or could ever occur. But if they do, then we must regard them as creative acts, as the continuous creation of a pattern that exists from all eternity, repeats itself sporadically, and is not derivable from any known antecedents. . . . Continuous creation is to be thought of not only as a series of successive acts of creation, but also as the eternal presence of the one creative act.

That same 1968 winter I made friends with a dirtbag ski enthusiast by the name of Jim Bridwell who was interested in improving his skiing. I let him join my ski classes without paying, and he offered a return payment in kind: If I ever wanted to learn to climb, just track him down in Yosemite after the ski season and he would show me around. In those days Bridwell spent half the year in Yosemite. That was before Doug invited me on the trip south, before meeting Dougal, and I wasn't interested in climbing and didn't think much about Jim's offer. A couple of weeks after Dougal took me climbing I had gained a different perspective, and after the ski season ended I went to Yosemite where I was welcomed into Bridwell's extremely counterculture camp within the more moderate counterculture of 1968 Camp 4.

For nearly a month I spent every day with Jim and some of his friends on the fine vertical granite of Yosemite, climbing as hard as my novice's developing skills would allow, and partying every night as hard as my veteran's developed skills could handle. It was a great time because of Jim's generous friendship and climbing guidance, but it was a few years before I fully appreciated that he was arguably the finest rock

climber of his generation, and the leader of a particular counterculture lifestyle of Yosemite climbing. So, though I was a novice climber on the morning of July 16, 1968, when the Funhogs first gathered in the yard of Chouinard Equipment to begin our journey, I possessed the rudiments of the climbing basics, taught to me by two of the greatest climbers of the time. I was about to expand that education on a climbing trip with three other preeminent climbers in America: Chouinard, Tompkins and Tejada-

Whatever one thinks about the *WSJ*'s journalistic standards or editorial policies, it is not a publication attuned to the values of the counterculture of the 1960s. Even the most active imaginations of 1968 would not have predicted it to ever publish a photo and story about the Funhogs. But all those years later, there we were in a photo taken July 16, 1968, at Chouinard Equipment with the Funhogs and Chouinard's then partner Tom Frost standing by the Ford van just before we began the journey south. The

"EVERY LIFE HAS THE SAME END, SO IT IS THE JOURNEY OF THAT LIFE, NOT ITS DESTINATION, THAT MATTERS. FREEDOM, SELF DETERMINATION, AND PERSONAL GROWTH ARE FOUND IN THE PRESENT MOMENT OF EVERY MILE, EVERY BREATH, EVERY MOVE OF EACH CLIMB, TRIP, AND RELATIONSHIP."

Flores. I wrote in my journal that night: "Chouinard I like immediately. He is open and warm and I know he can be tough. Doug and Lito are the groovy shits they are."

A month into the trip, in Peru, we picked up the fifth Funhog, one of England's top climbers, Chris Jones, just after he had finished a new route on the northeast face of Yerupaja. How could a counterculture-beatnik, hippie, dirtbag-ski-bum, gradschool-dropout, soon-to-become-a-confirmed-vegetarian, peace-lover, and Vietnam-war-protestor writer not tune into Jung's simple, direct perception of synchronicity as the continuous creation of a pattern? I mean, I was *supposed* to go climbing. I was *supposed* to go on the trip to Fitz Roy. I was *supposed* to be a Funhog.

We all were. It was the natural next exploration in the ongoing adventures of our lives. I don't think any of us in our wildest dreams could have imagined in 1968 where the Funhog trip would take us, or how it would influence and color our lives. More than forty years after that morning I was bemused to receive a phone call from a friend alerting me that I'd made that day's *Wall Street Journal*.

story was about Doug and Yvon, of course, and their separate but overlapping paths from dirtbag-climber luminaries to successful and wealthy businessmen, to world leaders in environmental and social justice activism.

No one in that photo would have imagined that in 2012 Tompkins would write,

Today there is growing recognition that wild nature is in a survival struggle, and that the fate of civilization is bound to the fate of the oceans and the climate. It appears that we are muddling toward ecological Armageddon and yet root causes are seldom explored and discussed. . . . The notions that people are in charge of nature, can effectively manage the earth solely for human ends, and can escape the ecological consequences of their own actions, are intellectually indefensible. Yet the entire collective human enterprise continues to be steered down these cognitive dead ends. Climate change, the extinction crisis, the depletion of resources of all kinds, and resulting economic social crises can be seen as the inevitable products of our collective delusional thinking . . .

it is essential that we shine a bright light on the delusional dogma of unending growth if we are to remake our economics under different terms, and share the planet in a way that allows evolution to flourish again. Anything short of that will lead to darker and darker days.

Doug's 2012 clarion call to action for a better world is rooted in the counterculture values of the 1960s, but offered in the awareness that the world's population has doubled since that time. As mentioned, synchronism is never singular.

We left Chouinard Equipment that day and a few days later we were surfing in Mexico, a new endeavor for me as noted in my journal:

Surfing is a bloody difficult game to pick up. . . . I had a great day but I have not yet ridden a wave. Tompkins is not too bad, Yvon is very

abilities to learn, to change, to grow, and to absorb the reality and lessons of the world. It also tested our ability to give back continuously while persevering in the face of every difficulty, detour and instance of implacable ignorance or deception. But the road was great fun, meaningful in ways we intuited, but would not understand until later.

We arrived in Mexico City a week after leaving California to find it bursting with preparations and energy for the upcoming summer Olympic Games. Those games turned out to be a milestone of the 1960s for several reasons. On October 16, black Americans Tommie Smith and John Carlos, gold and bronze medal winners in the 200-meter sprint, stood on the podium, received their medals, and gave what was termed a "Black Power" salute, but which they called a "human rights" salute. Their friend, silver medal winner Australian Peter Norman, wore a human rights badge on his shirt to show his support.

"AND THAT ROAD WAS A TOUGH GAME; IT WAS A CONSTANT TEST OF OUR ABILITIES TO LEARN, TO CHANGE, TO GROW, AND TO ABSORB THE REALITY AND LESSONS OF THE WORLD. IT ALSO TESTED OUR ABILITY TO GIVE BACK CONTINUOUSLY WHILE PERSEVERING IN THE FACE OF EVERY DIFFICULTY, DETOUR, AND INSTANCE OF IMPLACABLE IGNORANCE OR DECEPTION."

good. . . . He is very strong—the little guy in life who set out to show all the big guys that they must extend to keep up with Yvon Chouinard. And they must. . . . Lito (Fellini) played with his camera most of the day. It's incredible to watch him going gnomelike about his business with his shy-looking eyes and joyous grin. When he was done and I was tired and burned he tried my board. He, too, thinks it's a tough game.

Mexico, the first country we crossed on our long road south, set the tone for the journey, the climb, and our roads of consciousness and self-awareness. And that road was a tough game; it was a constant test of our

That gesture (and the photo of it) was a milestone in the civil rights movement in America.

For Smith and Carlos's courage and integrity, International Olympic Committee president, Avery Brundage ordered them suspended from the US team and banned from the Olympic Village. When the United States Olympic Committee at first refused on principle, Brundage threatened to ban the entire US track team from the games, which led to the shameful compromise by the USOC of expelling Smith and Carlos from the Games and sending them back to the United States. When Brundage was president of the USOC in 1936, he had made no objections

against Nazi salutes at the Berlin Olympics, arguing (in 1968) that the Nazi salute, being a national salute at the time, was acceptable in a competition of nations, while Smith and Carlos's salute was not of a nation and therefore unacceptable. Brundage and much of what he represented was a part of what the counterculture of the 1960s recognized had to be changed in order for there to be hope.

There is more to a journey than the drive, more to a climb than the mountain, more to a film than meets the eye, and a Mexico entry from my journal resonates with the spirit of the entire trip:

July 23, 1968. Mexico City. We met a girl named Wanda Klor who has a Mexican mother, a Russian father, was born in Mexico and raised in San Jose, California. She looks about 22, is only 17, and she offered us a room above her apartment. Her mother, naturally, kept close watch on Wanda and wouldn't let her go to dinner with us. But the room blew our collective and individual minds. Full of boxes, but newly painted in black and red, the first thing one sees are the giant letters WELCOME spread on the wall across from the door. The entire ceiling is a circular black stripe on red starting at the light and revolving out to the edge of the wall. (Or does it begin on the outside and work inward to the light?) On the wall on the right as one enters there is a square in red built of triangles against the black. Next to it is a peace symbol. The wall on the left is all red. It is very striking and reflects much thought, work, time, and, dare I say it, love. There were some collages she had done revolving around love, peace, brotherhood, and very reminiscent of the Bay Area scene.

We had a good sleep and this morning Wanda came by to say good bye before she left for work. The point is (or is there any "point" in nature?) that she gives with no reservations or questions.

She gives and that is enough. I will probably never see this girl again, though I would like to; but I, and I think the others, take something of her with me.

That is the point. The question is: what do we give in return and when and to whom? I feel it does not matter so long as we do give.

And on the evening of December 20, 1968, we reached the summit of Fitz Roy by giving 100 percent of ourselves to get there. I ended a 1969 *Summit Magazine* article about the climb with these words:

Afterwards, something remains beside the memory, but it is something else than the experience. It is like food for the spirit—it nourishes, giving strength for another day.

Just before the summit, when we knew it was in the bag, Chouinard summed it up, "Well, now we have earned our freedom for awhile."

The Funhogs were lucky. Sometimes you can give everything and still not reach the summit. But summits are less important than having hope, making change, and insisting on the freedom to seek personal growth and honest, internal reflection of the kind that, to paraphrase Tompkins, shines a bright light on every delusional dogma that views every redwood as the same while ignoring the hard, frightening reality that the earth's human population has doubled since the Funhogs climbed Fitz Roy.

Keep on shining, fellow Funhogs of the world, keep on shining that bright light.

Inside the second ice cave: canned food, cooking gear, and one of our trusty steel shovels (purchased in a hardware store on the drive down) used for digging ice caves. Without the steel shovels, we probably would not have been able to do the climb. The hard ice would have chewed up any US-made snow shovels of the time. - CJ

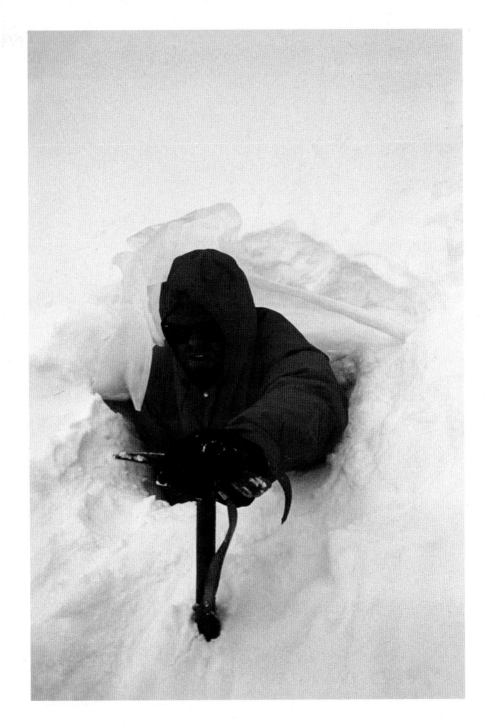

Dick, like a groundhog, emerges. - YC

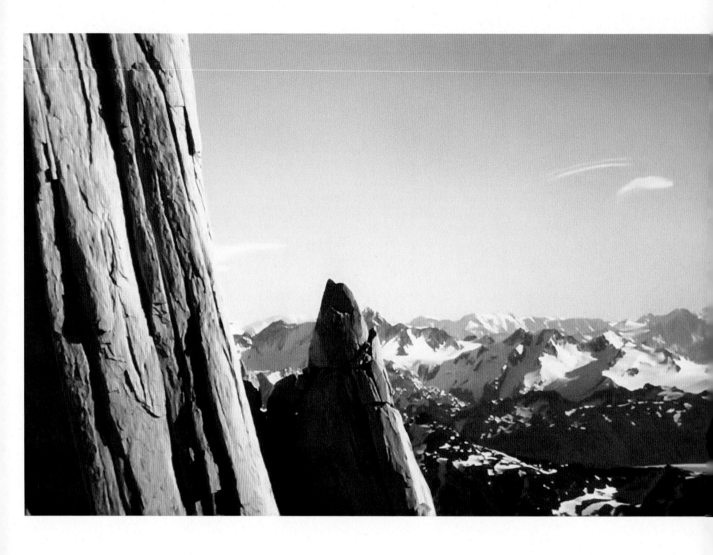

The impressive face of Poincenot seen from the Italian Col. Beyond, the many peaks of the ice cap. - CJ

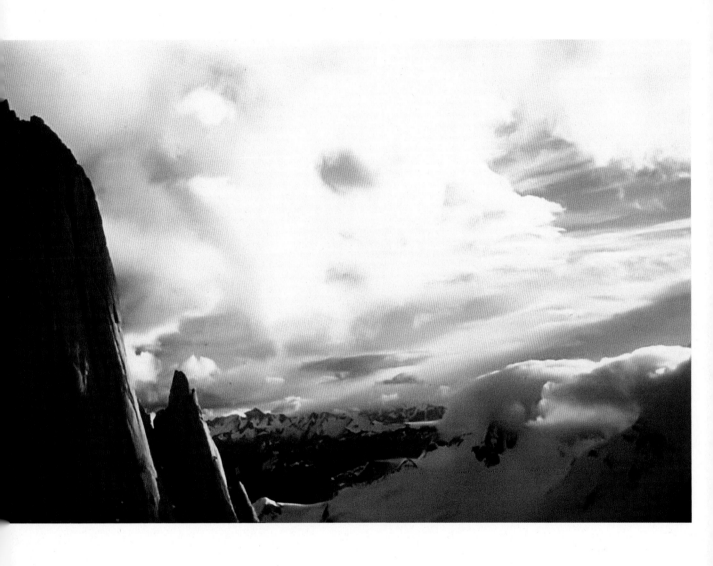

Storm clouds boil past in this view from the second ice cave. No climbing today! - CJ

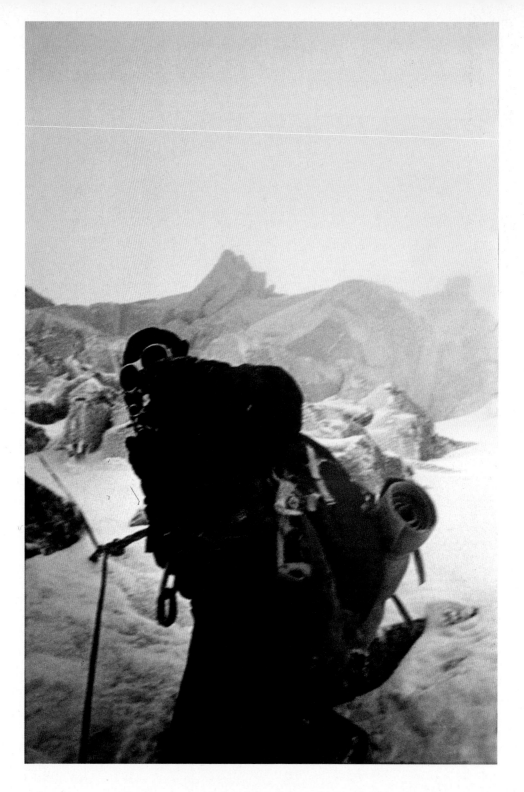

Filmmaker Lito seizes the chance to capture dramatic storm footage as we retreat from the Italian Col. - CJ

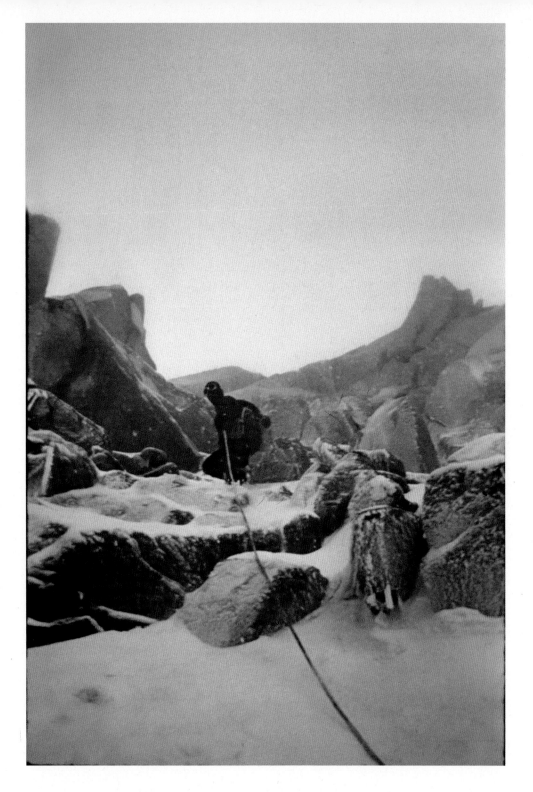

After fifteen days in the second ice cave, we retreat in a storm. Here, Lito rappels the couloir below the Italian Col. - CJ

Watching and waiting through appalling weather at our base camp. A mass of new snow covers these lower slopes. The mountain itself must have been far worse. - CJ

Dramatic clouds in a dramatic land: This view is from near our base camp in the woods. - CJ

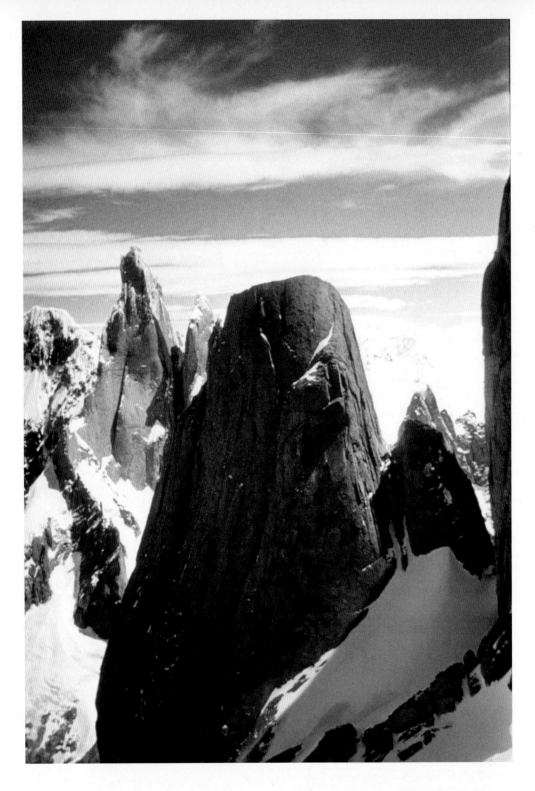

Cerro Torre in the background, with the Aguja Desmochada in the foreground, makes up the view from the second ice cave. - CJ

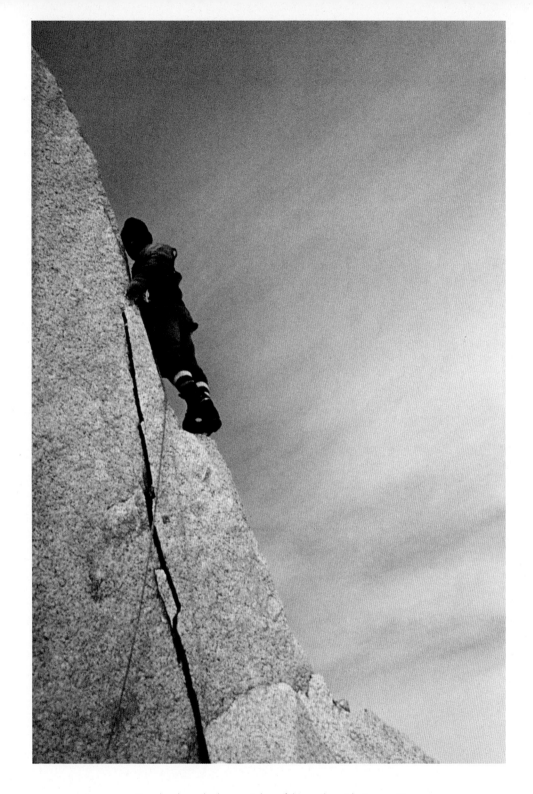

Yvon leads on the lower pitches of the southwest buttress. - CJ

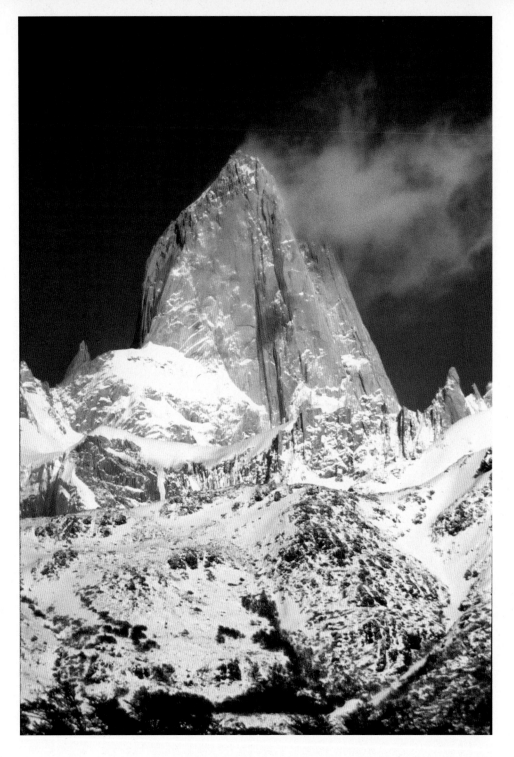

Fitz Roy's southeastern side. The Italian Col is the notch on the left. Snow slopes lead up to the base of the 1952 French route. The California Route goes left on hidden snow slopes to reach the foot of the southwest buttress. This is the buttress seen in profile on the left-hand skyline. - CJ

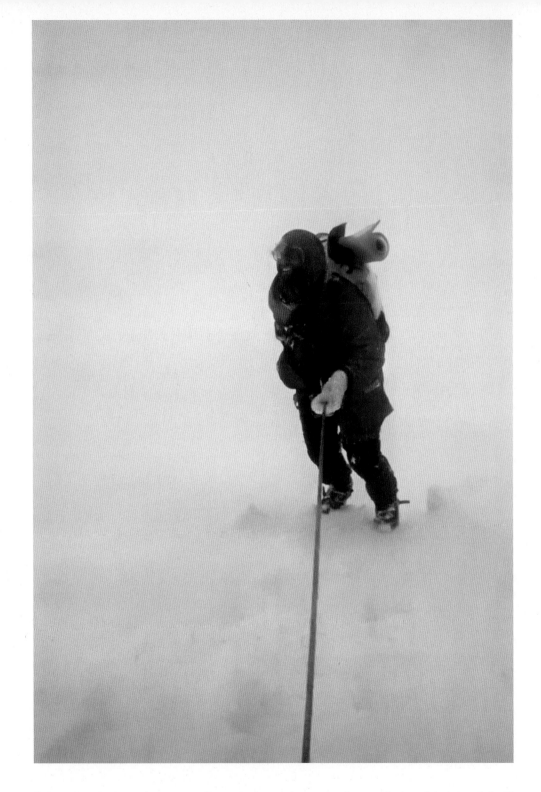

Dick peers upwards as other team members rappel to join him on the glacier at the foot of the Italian Col. - CJ

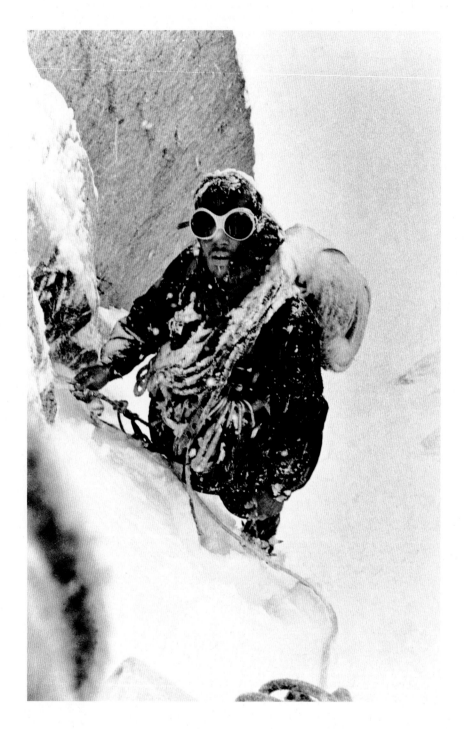

Doug descends from the second ice cave in a storm. - CJ

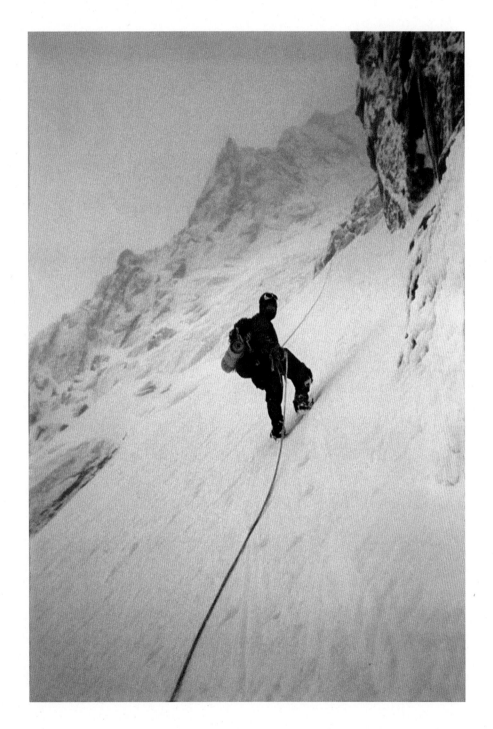

Lito rappels towards the glacier as we retreat from the second ice cave. - CJ

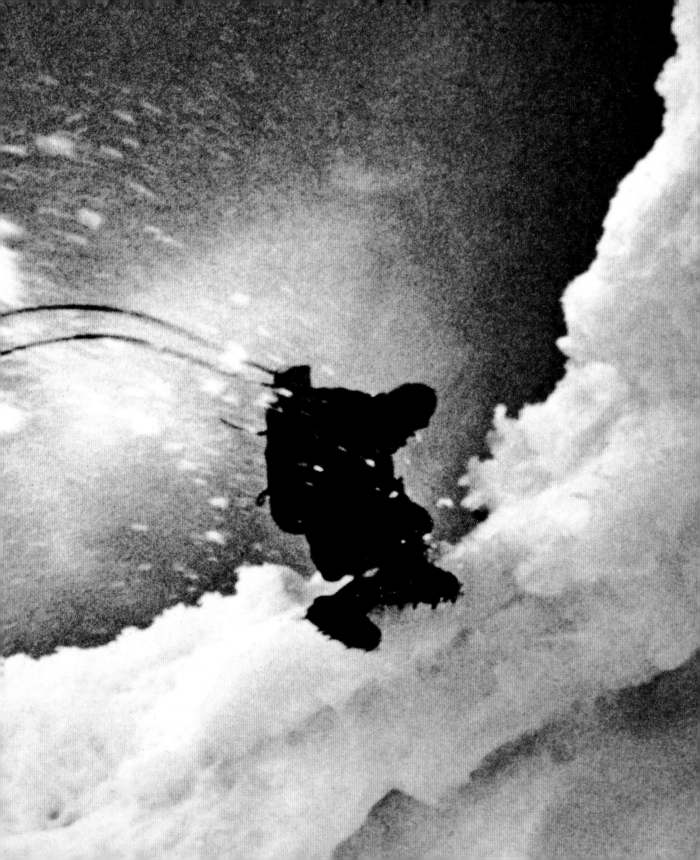

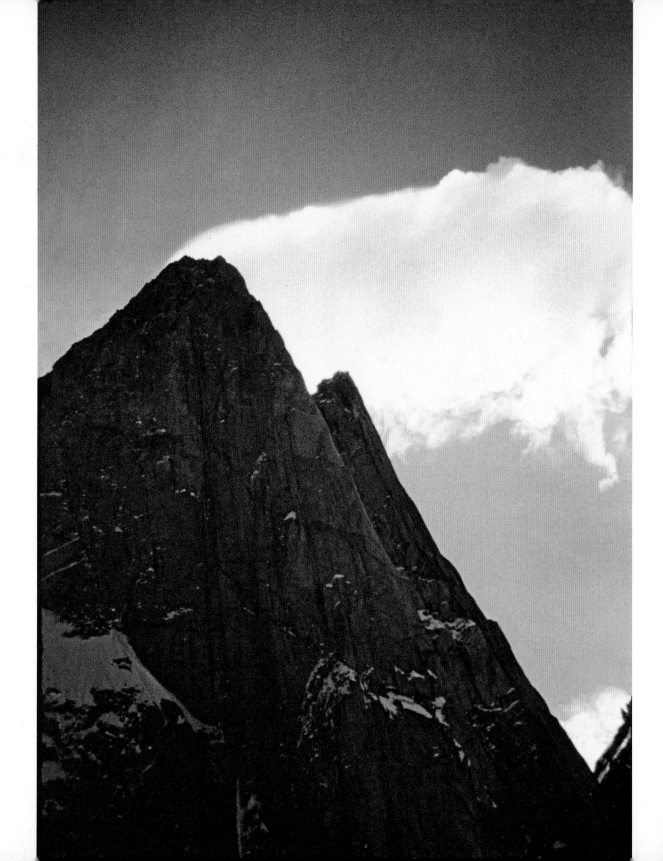

The Trip of a Lifetime
Chris Jones

Fitz Roy: It was the trip of a lifetime. But how it all came together and how the climb affected the climbing community is a story in itself. And that story centers on Yosemite, the scene there, and how that scene influenced the extraordinary members that made up the ascent party.

In 1964 I was in the French Alps, preparing to climb the Walker Spur of the Grandes Jorasses. My diary entry speaks of the first time I met Lito Tejada-Flores.

Back at Chamonix met Nick Estcourt, John Harlin, and Lito Tejada-Flores, the Anglo-American Dru West Face team. To lunch at the snack bar. Sat outside in rain with umbrellas. Harlin tells tales of shooting up lorries (while piloting jets in US Air Force). Very interesting bloke. To Le Choucas Bar and chatted to Lito about United States and San Francisco climbing. He has job offered at Leysin with John Harlin teaching skiing. Earned enough in US in 5 months to live for 2 years he reckons at $800 a month! Can't wait to move to either US or Switzerland - but which?

By his own account, Lito was then a pretty average skier—but he wasn't worried, he figured he could stay one step ahead of his students. In his biography, the noted French alpinist Pierre Mazeaud draws this picture of his friend Lito: "There too stood the remarkable figure of our American, born in Bolivia, resident in France, whose dream it was to die in Florence, and who, on top of all this, bore the incredible name of Tejada Lito de Flores [sic]."

The half-dozen or so American climbers we met in the Alps were a fascinating bunch; we British were in awe of their equipment and skill. I had to get over there!

The following year I arrived in California on a one-year work plan with IBM. After a year or so of steady work, however, I got with the program, quit my job, and moved to Yosemite Valley for the climbing season. Yosemite was then the most important and exciting rock climbing area in the world and increasingly visited by international climbers.

A couple of years later, in May 1968, the brilliant Argentine Jose Luis Fonrouge made his pilgrimage to Yosemite and completed an early ascent of El Capitan. Handsome and almost exotic, he cut a dashing, urbane figure, but what really set him apart in my mind was his astonishing second ascent of Patagonia's Fitz Roy with Carlos Comesaña a few years before. The Yosemite locals at that time were pretty parochial and had little idea of his accomplishments in the greater alpine world. Mick Burke, a fun and engaging British climbing friend with uproarious stories, was also in the Valley. He, Fonrouge, Pete Crew, and two other superstar Brits had been battling the astonishing Cerro Torre,

Previous spread: Lito rappels over the bergschrund as we retreat in the face of the storm. – CJ
Opposite: The local Indians called it El Chaltén. It is said that early European explorers thought Fitz Roy was a volcano due to the frequent clouds streaming from its summit. – YC

Fitz Roy's neighboring peak, a few months earlier. Patagonia, so remote and mysterious, was suddenly a place to consider. Sitting around the camp tables, we swapped climbing yarns and began to dream.

At that time, most Yosemite climbers were not interested in actually going to the remote mountains—although they could talk a good talk. This international schism between pure rock climbing and mountain climbing was borne out by one of Burke's stories. The weather in Patagonia had been atrocious; weeks went by as they waited for an improvement. Pete Crew, then one of the outstanding rock climbers in Britain, worried about what he was missing at home. "Can

at Squaw Valley, which he memorably referred to as the "Coney Island of skiing."

He lived sporadically in San Francisco's North Beach and had a tiny studio a short way from the notorious pole-mounted glass enclosure on Broadway in which a scantily clad young woman danced, hoping to entice passersby into the associated topless club. In 1967, I was also living in North Beach, which still retained many of its Italian influences, as well as those of the Beat Generation. Garish topless joints, downbeat bars, and other tourist traps dominated Broadway, so I was amazed to find a chic ski shop right next door to the notorious Condor Club and its

"AFTER A YEAR OR SO OF STEADY WORK, HOWEVER, I GOT WITH THE PROGRAM, QUIT MY JOB, AND MOVED TO YOSEMITE VALLEY FOR THE CLIMBING SEASON. YOSEMITE WAS THEN THE MOST IMPORTANT AND EXCITING ROCK CLIMBING AREA IN THE WORLD AND INCREASINGLY VISITED BY INTERNATIONAL CLIMBERS."

you imagine," said Burke, "here we were, among the hardest mountains in the world, and Pete kept obsessing on about these piddling crags in North Wales, and who might be beating him to the first ascents." Of course, Burke's story perfectly sets up the counterargument: Why suffer out in the wind and snow when you could be climbing sunlit crags—and likely getting much more climbing done?

Apart from the international cast of characters, Glen Denny and his crew, who were making a movie on El Capitan, were a big draw of the moment in Yosemite. This was a bold endeavor. The route they were filming, the Nose being climbed by Fonrouge and Rick Sylvester, was only seeing its 14th ascent. In order to make the movie, the film crew strung rope part way up the face to get to various points fairly quickly. On the crew was none other than my Chamonix friend Lito. Obviously he had stayed a step ahead of his students, as he was now working as a ski instructor

star performer, Carol Doda, the self-styled "Pioneer of the Topless Swim Dance." There seemed no logic in this juxtaposition, and the quixotic proprietor of The North Face, Doug Tompkins, was often found standing in his doorway looking on in amusement at the passing scene.

The California climbing community was so small then that I knew Doug by reputation before walking into his store. He was full of energy and charisma, and seemed way too full of ideas to be in such an odd location. As he was not a regular in Yosemite, I had little idea about his climbing background. On the other hand, I knew a lot about his friend Yvon Chouinard. He was one of America's leading climbers, with already legendary ascents in Yosemite and elsewhere. He was one of the dozen or so who had initiated what was becoming known as the Yosemite school of climbing—the very experience that I had come to find in the first place.

In 1967, Yvon and I were both in the Tetons when he proposed a trip to Canada. His 1950s-era Chevrolet was just up to the task as he and I and two compatriots rolled up to the border crossing. The guard looked us over and demanded we produce evidence that we were not going to be freeloading off the Canadian government. We barely passed the test. In Canada, Yvon tended to the Chevy more than once, coaxing it back to life. He had a fascinating series of ideas on climbing and on life. Very much a vagabond, he had a fear of creeping domesticity even then: "Jones, never, ever, own a lawnmower—it'd be the end." He had all manner of plans tucked away, while we hardly knew the names of any Canadian peaks.

Returning to the spring climbing season in Yosemite in 1968, my partner Dick Erb and I retreated from El Capitan in rain and hail just shortly after Fonrouge had climbed the same route. Only about one party in eight was then successful on these enormous climbs—the mental barrier was overpowering. Packing up my gear to leave the Valley, I was now focused on a trip to Yerupaja, the highest peak in Peru's Huayhuash mountains. In chatting with Fonrouge, I learned he had been scouting my intended route on Yerupaja. No time to waste.

Leaving Yosemite in early June, I was unaware that Doug, Yvon and TM Herbert had plans to make the sixth ascent of El Capitan's fabled Salathé Wall. Nor did I connect with a new guy in camp, Dick Dorworth, who was getting an initiation by fire with local hotshot Jim Bridwell. All the Funhogs were in Yosemite that spring of 1968, which is only fitting as the Valley played such a crucial role in forming the climbing and life experiences of us all.

Before I left, Doug and Yvon had formed a plan for a road trip unlike any other: driving some eight thousand miles from California to Patagonia, surfing and skiing along the way, and finally climbing in the Fitz Roy massif—and making a movie of the whole

affair. Knowing they would pass through Lima, Peru, where I would be, we made a tentative plan to join up if the timing worked out.

On August 15th, our Yerupaja team returned to Lima from our successful climb and were soon hard at work writing a derring-do article for *True, #1 Man's Magazine*—we were quite shameless. The Funhog road trip was pretty much on schedule, and a few days after our arrival, Yvon came round to the apartment where we were staying. Just a week later I joined the Funhogs and we were rolling south.

As we worked our way down toward the eventual goal, other forces were in play. In London, Ken Wilson was launching a new publication, *Mountain*, which would be the first English-language magazine to look at climbing in an up-to-the-minute and vibrant way. He would put out what became known as the Patagonia issue. Here, for the first time, was a thorough look at this then largely unknown area. That he should have chosen to highlight Patagonia before any other mountain range in the world said all one needed to know about the coming prominence of that storm-lashed, ice-plastered range.

Ken and I had shared a flat in London some years before and, once finished with Yerupaja, I dropped him a note. Ever on the lookout for some drama, he used my information to conclude in the first issue of *Mountain*, "Jones is at present in the Fitz Roy area, with Americans Yvon Chouinard and Lito Tejada-Flores attempting a big, and so-far secret climb." The secret part was all in Ken's imagination, but it made good copy.

By simply going to Patagonia, we were throwing our hats into quite different ring. After an early discussion in Mexico, Dick Dorworth noted in his diary,

A revelation—the next big step in climbing is a continuous assault on a big wall under alpine

conditions. Thus Fitz Roy, thus Chouinard, thus the entire expedition. I know today after my talk with Yvon that we will make climbing history down there. The spectrum expanded, became more intricate, more beautiful, and more clear.

Yvon is what might be termed a climbing philosopher; his 1963 article in the *American Alpine Journal*, "Modern Yosemite Climbing," was highly influential. He concluded by saying,

> *The future of Yosemite climbing lies not in Yosemite, but in using the new techniques in the great granite ranges of the world . . . the innumerable ranges of Alaska, the Andes, and the Baltoro Himalaya all have walls which defy the imagination. . . . Yosemite Valley will, in the near future, be the training ground for a new generation of super-alpinists who will venture forth to the high mountains of the world to do the most esthetic and difficult walls on the face of the earth.*

In a related article, "Games Climbers Play," in the first issue of *Ascent* in 1967, Lito defined super-alpinism, saying,

> *This is the newest climbing-game to appear and is not yet completely understood. It rejects expedition techniques on terrain which would traditionally have been suitable for it. Its only restrictive rule is that the party must be self-contained. Any umbilical-like connection in the form of a series of camps, fixed ropes, etc., to a secure base is no longer permitted. . . . Some of the early, classic super-alpine routes were the South Face of Aconcagua, the ascent of Cerro Torre by Egger and Maestri, and the first winter ascent of the Eiger North Wall.*

The question was could we climb as well as we could theorize?

We had with us Azema's *The Conquest of Fitz Roy*, an account of the 1952 first ascent by French alpinists Guido Magnone and Lionel Terray. A riveting passage grabbed our attention: "But it was on the right, the east flank, that Fitz Roy presented its most formidable aspect. . . . There had never been such a challenge to the climber's ambition. Would future generations attempt this eastern pillar?" We were fascinated by the possibility, and earnestly discussed various technical problems. When we reached Bariloche, Argentina, we saw detailed pictures of Fitz Roy's eastern side for the first time. It was sobering. Jose Fonrouge joined us there and climbed with us on the local crags. As an alternative proposal, he got us fired up about the route on Cerro Torre that he had attempted earlier in the year.

None of these pictures or discussions, however, quite prepared us for the breathtaking first sight of Fitz Roy. As a later writer said, "It stands alone, leaving every alpinist that has laid eyes on it stunned." Terray considered Fitz Roy his most difficult climb, perhaps then the most challenging alpine climb in the world. It was no doubt Fonrouge who had suggested that we use the French camp in the beech forest, with its rudimentary wooden structure, as our base. We recognized it immediately from the familiar photo in Azema's book. On a broken packing case we saw a moving reminder: "Expedition Maestri 1959 Cerro Torre." We knew that possibly the foremost climber of the mid-twentieth century, the Italian Walter Bonatti, was himself unsuccessful on Cerro Torre. Simply put, our predecessors' names alone psyched us out. We were climbing more than mountains; we were battling the history, the very mythology of the sport.

Before committing to Fitz Roy, Yvon, Dick, and I went to examine the possibilities on the otherworldly Cerro Torre. I later wrote,

82

The severity of the Torre canyon, desolate and bleak, was a hard awakening. On the glacier the physical presence was staggering—the wind pushing us down, its turbine roar frightening— the mountain faces too large to comprehend. Back at the Cerro Torre base camp we didn't say too much. We had planned to leave our ice axes and crampons; when Yvon suggested it was no bother to take them, I didn't see the significance. But when he removed food from the cache, the meaning was only too clear. We were not coming back.

Doug and Yvon had invested money in the film project, and our chances of climbing Cerro Torre and filming it were about nil. With thoughts of both Cerro Torre and the east face of Fitz Roy abandoned,

We were not totally naive in our ambitions, however. We had advantages over previous teams in Patagonia. The hard-steel pitons designed and manufactured by Chouinard were clearly better and faster to use than the European ones previously employed. (We also had early models of Chouinard's new rigid crampons, although these were not a decisive factor). The key was having the equipment for, and familiarity with, climbing and living on Yosemite's huge walls, a skill that our predecessors lacked.

In 1952, Terray's team considered attempting our climb, which became known as the California Route, but for various reasons preferred the face directly above the snow saddle. To us, their route appeared as the more difficult alternative; we were thrilled to find not only a new route, but a logical way to the top.

"OUR FIFTEEN MINUTES OF FAME WAS STRICTLY LIMITED TO THE CLIMBING WORLD, AND WAS SOON TO DRAW TO A CLOSE. LATER WRITERS CITED OUR CLIMB AS JUMP-STARTING GREATER INTEREST IN PATAGONIA; WITHIN A FEW YEARS THE CALIFORNIA ROUTE BECAME THE MOST FREQUENTED ROUTE TO FITZ ROY'S SUMMIT."

we headed up towards the French route on Fitz Roy. But even if we had no filming to do, in retrospect it was clear that both projects were beyond what we had in mind—a super-alpine climb as described by Lito and Yvon in their writings—or were capable of doing.

The British on Cerro Torre and climbers on Fitz Roy's east face used ropes fixed in place as they progressed; expedition-style climbing. It would be many years before those making first ascents of such a scale in Patagonia would have sufficient confidence to cast off the umbilical cord to safety. The generation to truly climb here in super-alpine style had yet to arrive. Climbers had to improve skills, gain knowledge and confidence in Patagonia conditions, and bring yet-unknown equipment to withstand the weather.

We made the right decision and the climb was a success. After about seven months on the road, we arrived back in San Francisco on New Year's Day, 1969. There to greet us was Doug's vibrant, attractive wife, Susie. At least our wives and girlfriends cared, but for the rest of America, it was a nonevent. Climbing was then such an oddball activity that it was almost a liability to even mention it in social or work situations.

But luckily it was not so when we gathered in Trento, Italy, the following September for the international mountain film festival. Lito's brilliant film, *Fitz Roy: First Ascent of the Southwest Buttress*, took the first prize—the first non-European film to do so. In that gathering of the world's preeminent adventurers, to have climbed Fitz Roy was the coin of the realm. At the annual meeting of the American Alpine Club

that winter, the film and Yvon's slide presentation received a standing ovation; quite dramatic from that reserved group. Our fifteen minutes of fame was strictly limited to the climbing world, and was soon to draw to a close.

Later writers cited our climb as jump-starting greater interest in Patagonia; within a few years the California Route became the most frequented route to Fitz Roy's summit. Though we had not pushed the frontier as we had imagined we might, at least we had established a sought-after route. By the late 1980s a variant to the French route came into favor as the new path of choice. By one contemporary estimate, some 90 percent of all ascents are now made by this route or ours. The subsequent history of the Fitz Roy area was beyond our earlier imaginings.

This can be measured, in part, by the later story of the paths we failed to take. The east face of Fitz Roy was climbed via the East Pillar by an Italian team in 1976, after successive attempts in the early and mid 1970s; fixed rope was used extensively on these climbs.

The other route we briefly considered, the southeast ridge of Cerro Torre, was not pushed through until

In 1970, Maestri came to Cerro Torre with a large team in winter. At first unsuccessful, he returned the following spring. He continued the line of the 1968 British attempt by inserting over 300 bolts with a gas-powered compressed-air drill, an unheard of and controversial tactic. Writing of this outrage, Doug Tompkins perceptively noted,

It is immensely unlikely that anyone who climbed such a peak as Cerro Torre, in a brilliant, alpine-style, lightweight manner, would later return to blast his way up the same mountain. . . . That is to say, the very manner of the 1970 ascent gives the lie to any previous ascent! As to the validity of the new machine-made route, we may say that, although regrettable, it has at least cleared up our doubts about the Maestri/Egger ascent.

Without going into the polemics against Maestri's machine-bolted climb, which continue to this day, it became the route of choice. It was the surest way to the summit of one of the most iconic mountains on the planet. Attempts to actually climb the rock and ice involved, as opposed to following a line of bolts, were put aside for decades. As for Maestri's 1959 route, it became more and more implausible with the

"BUT THE ADVENTURE WAS MORE THAN THE CLIMB ITSELF. THE EPIC ROAD TRIP, THE FILM, THE SURFING AND SKIING, THE VARIOUS STORIES THAT HAVE BECOME CAMPFIRE STAPLES AND, OF COURSE, THE NOW-LEGENDARY PARTICIPANTS THEMSELVES."

attempts in 1999 and then 2007. The reason for this is caught up in the puzzling, even bizarre, history of Cerro Torre itself. Although most climbers accepted Cesare Maestri's claimed 1959 ascent of Cerro Torre, the details were vague. The camera was lost when his teammate, Toni Egger, fell to his death on the descent, and there were inconsistencies in the story. Seeing this route from Fitz Roy, we ourselves could barely believe the skill and daring involved.

passing years. When teams eventually climbed on or near the claimed route, it was apparent that Maestri had never even been high on the wall. It was a fiction.

Today, though largely lost among more difficult routes, the California Route still retains some cachet. For its 2002 centenary issue, an advisory team of the *American Alpine Journal* was tasked with nominating the hundred most significant climbs of the club's

first hundred years. Our route made a short list of some 200 climbs, but a final vote never took place. In 2004, a lavishly illustrated new climbing magazine, *Alpinist*, profiled the charismatic Fitz Roy. Lito provided a snappy story of our climb, just one of six routes so highlighted out of the thirty-odd then established.

Our adventure lives on; it still captures the imagination of present-day climbers. One such climber recently characterized Lito's film as "the seminal dirtbag epic." In historical importance, our climb is overshadowed by the earlier ascents of Terray and Fonrouge. Those were truly groundbreaking. But the adventure was more than the climb itself. The epic road trip, the film, the surfing and skiing, the various stories that have become campfire staples and, of course, the now-legendary participants themselves.

Looking back, helped by these long-lost photos, I am reminded of walking the final steps to the summit. The crunch of snow underfoot, the bantering with cinematographer Lito to get a move on, the menacing weather, and our sheer excitement and relief. No summit before or since has ever meant as much to me.

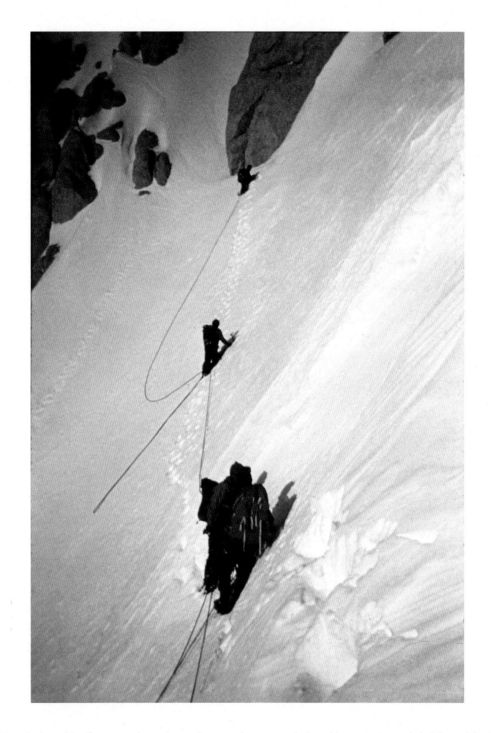

Doug, Yvon, Dick, and Lito (from top to bottom) cross the snow slopes towards the col between Aguja de la Silla and Fitz Roy. - CJ

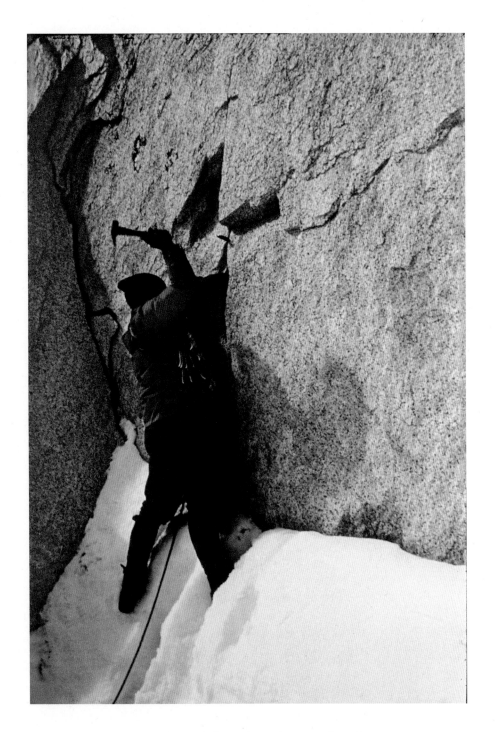

Doug places a belay anchor on the summit day. - CJ

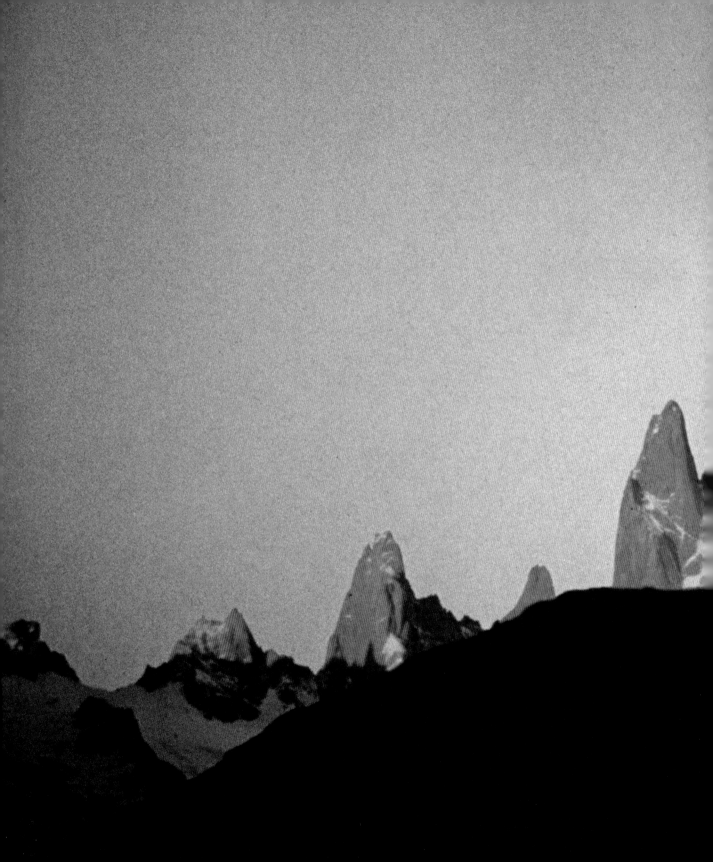

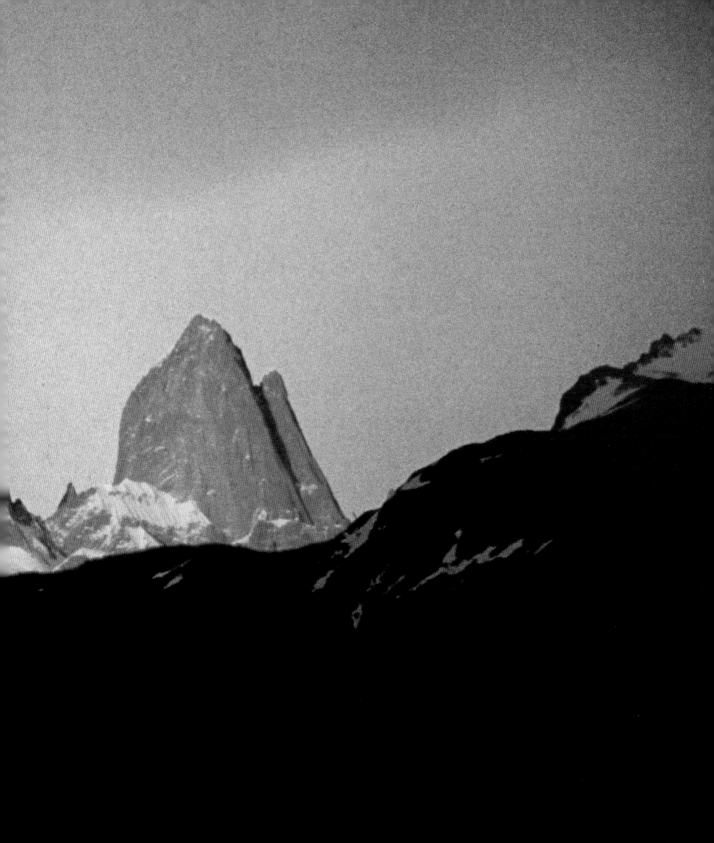

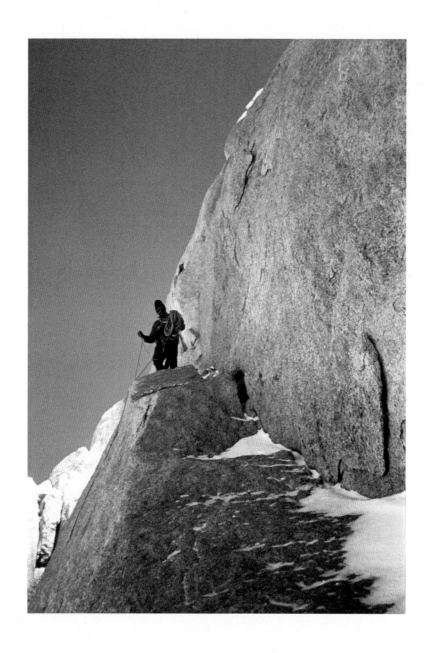

Previous page: The Fitz Roy group bathe in an eerie evening light. - CJ
Doug coils ropes at the end of a rock ramp dusted in snow. - CJ

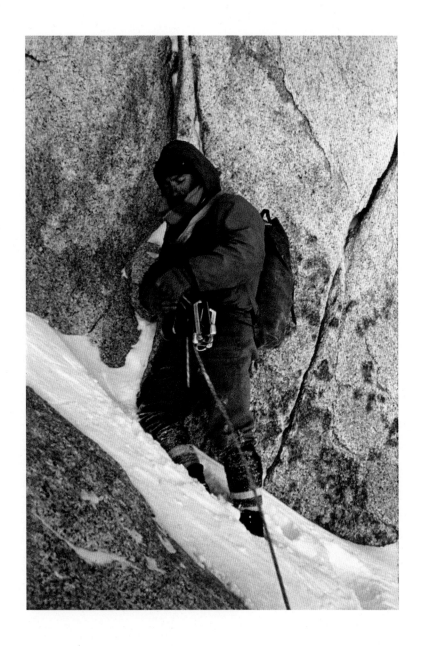

The fingerless mitts are a real treasure in the early morning on the summit day. Being on the southwestern side, it is a sunless and bitterly cold morning. - CJ

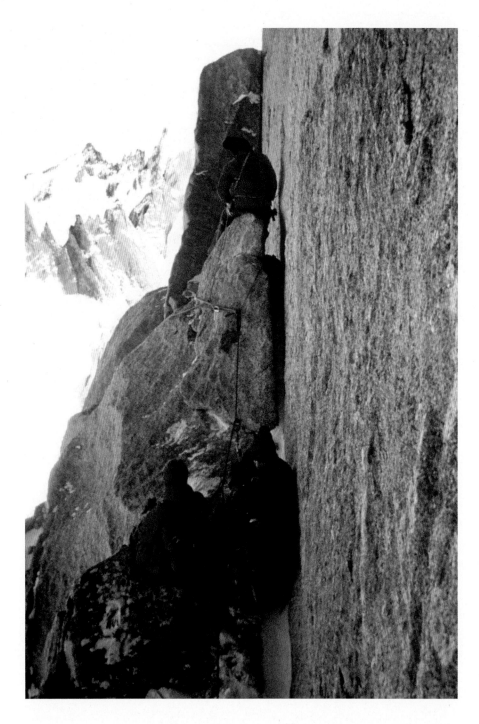

Doug belays Yvon, who is on lead and out of the picture. Dick (left) and Lito follow the action. - CJ

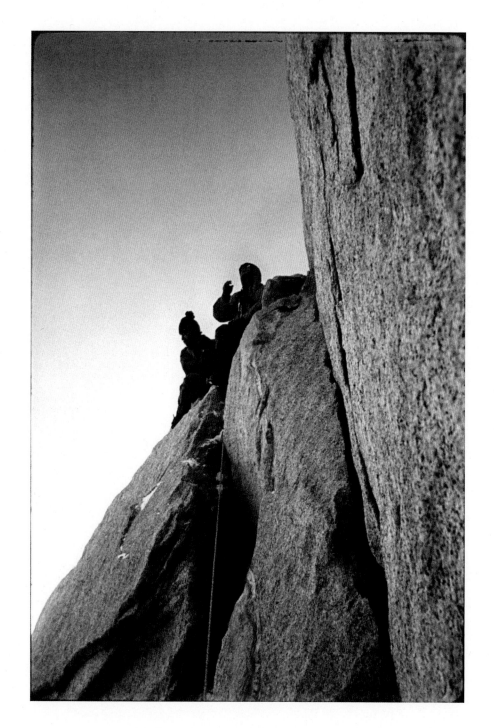

About midheight on the route, Lito and Dick set up a belay stance. - CJ

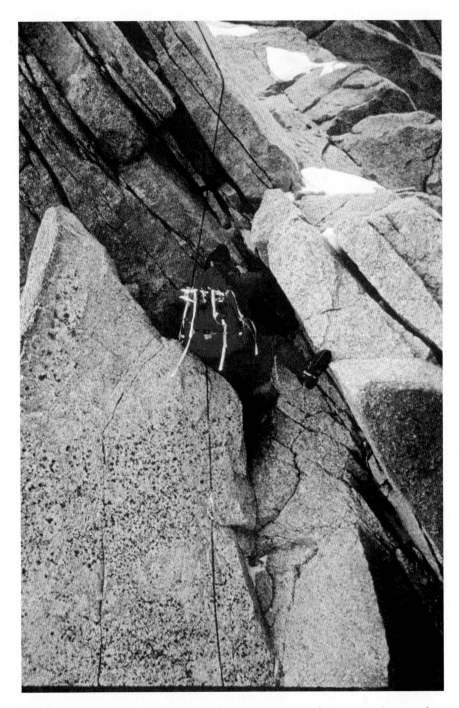

Lito follows up a slabby corner, trying to find the best positions in order to capture the action for the proposed movie. - CJ

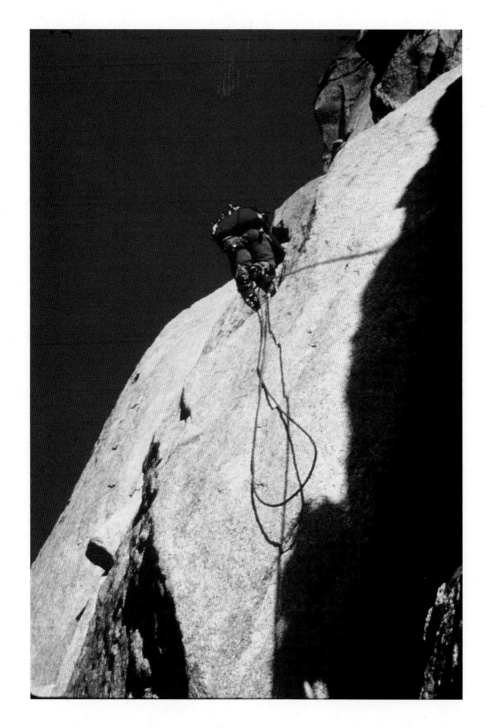

Finally, we break out into the sun after a chilly day. Here Lito hurries up to see the way ahead. - CJ

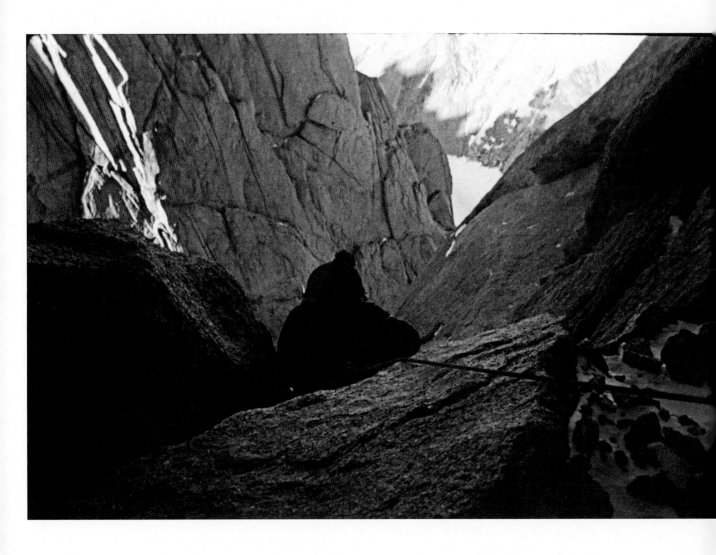

With the sun just striking the Aguja de la Silla, Lito follows ropes in cold conditions. - CJ

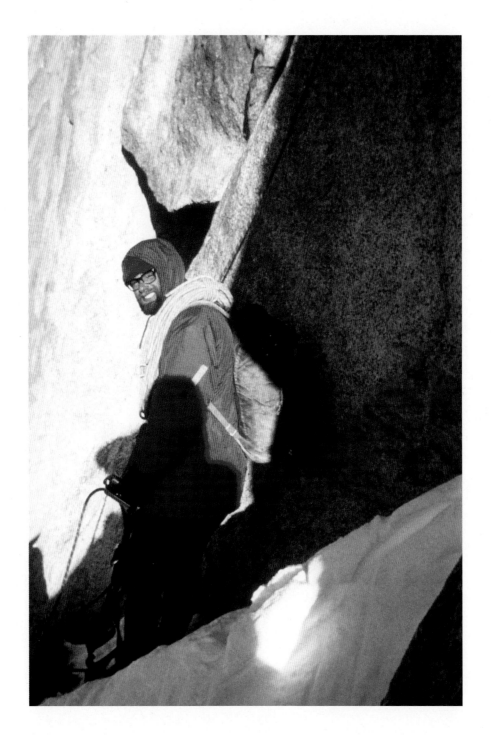

In the warming sun at last, Dick grins at the camera as he waits to move ahead with rope for the leaders. - CJ

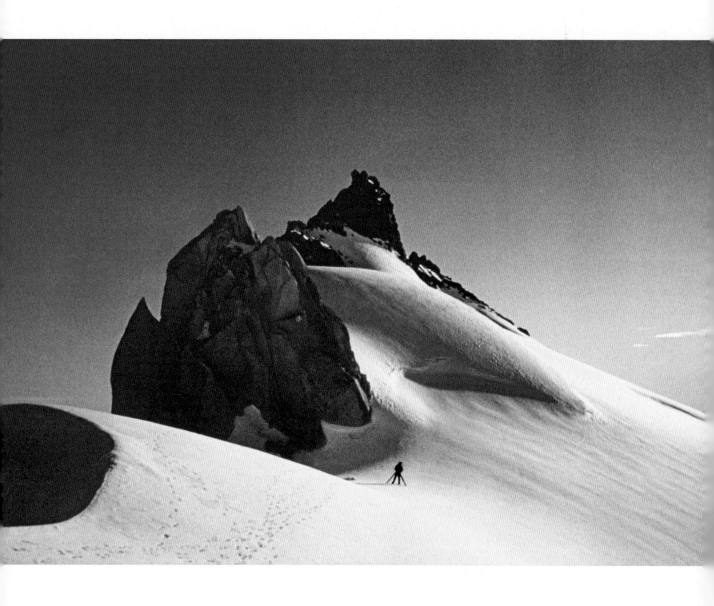

Lito sets up the camera tripod close to the entrance to the first ice cave. - CJ

The Way it Wasn't

Inventing Memories at Twenty-Four Frames Per Second
Lito Tejada-Flores

You never climb the same mountain twice, not even in memory. Memory rebuilds the mountain, changes the weather, retells the jokes, remakes all the moves. The Fitz Roy I remember isn't really the Fitz Roy we climbed—but it'll do. Where do these untrustworthy memories come from?

There was a mountain, and there was a base camp in the tangled beech forest below it. There was a long slow season: looking, scouting, planning, but mainly waiting. And there was a climb; there were multiple climbs—up and down, and up again, and down again, but mostly just waiting around. Waiting for the weather, for one final climb to the top of the Fitz, which really happened. I brought back the proof, in a silver can filled with a hundred-foot, daylight-load spool of Kodak ECO 16 mm color film.

And that was just the beginning, the beginning of another climb, to another summit, another patient slog, kicking steps up the steep learning curve of documentary-film editing—just like kicking steps up long slopes of wind-blasted snow, carrying loads—reliving the climb, scene by scene. But only reliving the scenes I had managed to film, looking for threads to tie those scenes into a story—a real story, not exactly the real story, but a story that made sense—our story.

Film editing for me seemed like "The Adventure, Part II." It was a brand new skill I had to learn after we climbed our mountain and returned from South America, after I finished my winter of ski instruction at Squaw Valley and settled into a hillside cabin—almost a tree house—in Sausalito. Up there above the Bay, I had a Zeiss Moviscop viewer, a pair of rewinds, a guillotine film-splicer, and several trash barrels in which I hung hundreds of feet of 16 mm work print. All that, and a film to make.

Film editing, I soon discovered, is a form of time travel. Back-and-forth from then to now, and back to some different then, to a time that seemed almost as though it was happening all over again as I stared at the tiny glowing screen on my desk. The challenge was to condense two months of real time into half an hour of movie time—without really losing anything. Impossible, of course, but what the heck. I was substituting filmed memories for other more visceral, internal memories, both more detailed and more diffuse. And slowly, first in my mind, and then on the screen, the whole trip, and our climb of Fitz Roy—that perfect climax of a six-month journey down the long axis of the Americas—became a film.

Our journey had a plot, but even that plot, or at least the inspiration for it, was connected with a film. It started with *The Endless Summer*, Bruce Brown's classic surfing feature about searching the world for the perfect wave. But we were climbers first, then skiers (some of us), then surfers (some of us), friends (all of us), and looking back, we were also free spirits, free agents, or just plain free. Free to take off for six months, head south, and see what happened. Even more than a plot, we had a goal. The goal was Patagonia, and a major Patagonian climb. Today, topo guides to every serious climbing route in Patagonia can be found on

the Internet, but in the late 1960s, Patagonia was a mysterious, seldom visited, but already fabled region of granite spires hidden down at the end of South America—a perfect and perfectly remote destination for a bunch of California Funhog climbers.

Yes, it really was a climbing trip, a climb with the longest approach in (our) history: We left Ventura, California, in a used Ford van—loaded with skis, surfboards, and lots of climbing gear—and headed south. I was invited along to make a film, to be modeled after *The Endless Summer*. We would drive, surf, and ski the length of the continent and end up on top of a grand granite spire in Patagonia—seemed like a good plot.

Before we left, Dick Barrymore, one of our generation's best ski-movie makers and a wonderfully generous guy, gave me a one-day crash course in 16 mm color film exposure. I hoped that was all I needed. How hard could it be? My wind-up Bolex camera would expose each frame of film for one-fiftieth of a

Inevitably, the moments and scenes that I was able to film became fixed in a kind of parallel memory, frozen for all time to the gentle tick-tick-tick of my Bolex as its wind-up spring unwound south. Always south.

There were moments, of course, that I couldn't film. Like being woken up in my sleeping bag outside of Antigua, Guatemala, by a click that, as I opened my eyes, I somehow knew was the bolt of a carbine pulled back to chamber a round. Desperately pulling together all my knowledge of Spanish, I tried to explain to a frightened irregular, who was pointing his weapon at my head, that we were only tourists, *turistas, sí, solo deportistas*, only interested in sports, not subversion. Or those sticky hot moments in Panama City as we tried to get permission to put our Ford van on a freighter to Cartagena, Columbia, in order to detour around the Darién Gap. That afternoon, Doug and I ran sweating from one shabby, claustrophobic government office to the next to get too many papers stamped with too many official stamps: Latin American bureaucracy at its best. That was my

"INEVITABLY, THE MOMENTS AND SCENES THAT I WAS ABLE TO FILM BECAME FIXED IN A KIND OF PARALLEL MEMORY, FROZEN FOR ALL TIME TO THE GENTLE TICK-TICK-TICK OF MY BOLEX AS ITS WIND-UP SPRING UNWOUND SOUTH."

second. So all I had to do was set the aperture, right? I figured I could handle that. But when we reached Mexico City and found a film lab that could develop our first rolls of film, my confidence was shaken. There wasn't a single decent shot. It turned out the pressure plate inside my Bolex hadn't pressed the film firmly into its guides. Every single shot of surfing along the Mexican coast was ruined by wild, fluttering vibration. This was the last footage I would see until we got home, six months later, so the rest of my filming adventure turned into an act of faith. For once, blind faith—plus careful attention to the pressure plate—worked. And for me, right from the start, the trip and the film began to blur together.

Panama City, not Dick Dorworth's, or Yvon's. It was only much later I realized that each of us was living, and would remember, a different trip, even though we all piled into the same van every day to head south together. South. Always south.

South through Columbia and Ecuador. South along the coast of Peru. Skiing down coastal sand dunes under foggy skies, or trying to. And me, trying to film it. Cresting each new pass to find one more immense view of endless ridges, endless Andean terraces. And more than once this same dialogue:

"OK, Fellini, why don't you film this?"

"Film what?"

"Film this, all this, all of it. . . ."

All of it: the unfilmable crazy-quilt of the world, unrolling south, along an early and very unpaved version of the Pan-American Highway, winding and unwinding its way south—always south, kilometer after kilometer, day after day, week after week.

More than three months after leaving Ventura, watching (and filming) Yvon take the engine out of our van on a sidewalk in downtown Santiago, Chile, then waiting a week while Yvon rebuilt the engine in a local machine shop. And on we rolled, driving through southern Chile with its dense forests and snow-covered volcanoes. Skiing too, but on snow, not sand dunes this time. I remember, or think I remember, drinking the alcoholic chicken broth of *pollo al cognac* in a ski lodge under the Llaima Volcano while snowflakes drifted down through the monkey-puzzle araucaria trees outside.

There were other moments that never got filmed but still stuck fast in my memory, like bluffing our way into Argentina, using a two-dollar rubber stamp to modify the van's customs documents. And Chris Jones, our ace mathematician, figuring out that we'd need at least 200 pounds of sugar on the basis of one teaspoon per cup of tea, per meal, per man. Laughter all around. Then buying a couple of pounds of sugar in Bariloche and heading on south though Argentine Patagonia, a lonesome dirt road through a lonesome dirt landscape. This was the real Patagonian steppe at last, but where were the Andes? Where were the peaks?

Then suddenly the traveling was over, and the climb was starting. But starting slowly. An overnight horseback ride with a couple of soldiers to the border outpost of La Florida produced a few more horses to take our gear up to a base camp under the peaks—and left

me almost too sore to walk the next day. I remember how my spirits lifted when Yvon figured out that Cerro Torre might be too much, and Fitz Roy would be a more reasonable goal. Fitz Roy was, by comparison, a gentle giant. No, not so gentle, but definitely a giant. Days passed finding the route, carrying loads, filming; my months of practice with the Bolex camera were paying off.

Up we went, onto the lower snow and glacier slopes of the Fitz, happy that we had scored some really stout steel shovels in Bariloche to dig caves in the hard, hard snow. (Why did we always call them "ice caves" since we actually dug them out of wind-packed snow?) Glacier trudging soon morphed into real climbing. The first steep pitches took us up a rock wall to a col, then around the corner onto a horizontal shoulder sticking out from the base of the enormous granite bulk of the Fitz. Time to dig a second ice-cave camp up there on the *Silla* (Spanish for "seat") under the real and final rock, the real Fitz Roy, a giant granite finger in the wind. Getting to know the wind, staggering around in the wind, wind-whipped snow looking great through my viewfinder—but not so great for climbing. Hiding from the wind. Then back up to the Silla with more food for more waiting, waiting for the wind to slack off; more wind, more waiting. Ready to go, settling down to wait for that clear day that doesn't come, more waiting. We could almost taste it.

Weeks of waiting, snug as a bug in an ice cave, telling boring stories, cooking boring food, writing a Funhog's gourmet guide to the world in Dorworth's tiny spiral notebook, complete with complex food rating systems. Complex memories, simple conversations, always damp under the ice. Weeks of getting nowhere, going nowhere, day after day, scraping snow off the entrance of our cave, seeing nothing.

The mountain out-waited us. No more food. We retreated back to base camp in a howler of a storm.

Before starting down, I put a superwide 10 mm lens on my Bolex—no need to focus that lens. I couldn't anyway. And halfway down the col, I got one chance at changing film, so I hunkered down on a ledge with the camera inside my cagoule and one of the lads leaning on me. Another one hundred feet of film loaded and on we went, down through the storm, rappelling over the last lip to the glacier, white on white, roped climbers wandering off into pure white, a perfect picture. Was it really that way, or only on film?

Back in base: base-camp boredom just a variation on a bigger theme. Hiking back down to the road and driving out to buy more food at the nearest crossroads country store—and more wine, we were in Argentina after all. Chasing a lamb all afternoon, and then, a couple of amateur butchers that we were, butchered it. Arggh! Then back up through the forest, back into heavy waiting mode, making up crossword puzzles, devising fiendish traps to kill the mice that were eating the flour reserved for Yvon's bread. Morning body count: half a dozen dead mice floating in a cook pot of water after walking the plank and leaping for the suspended cheese. These complicated Rube Goldberg traps always got their mouse. Hikes to nowhere under stormy skies, rain in the forest, some filming, but not much, waiting becoming a lifestyle, time almost stopped.

Nothing lasts forever—but everything lasts for some time, and sometime always ends. A break in the weather says go, and we go. The weather says yes, and we say maybe, and keep going. We know the route back up to our ice cave on the Silla on autopilot, counting on one clear morning. Stuffing more cans of film into my pack for tomorrow.

Tomorrow becomes today, still clear and cold. So cold that my faithful Bolex almost goes on strike. It doesn't sound right. It isn't. Water vapor from our damp cave has frozen inside the camera, and it's ticking like a pocket watch in glue. I know the sound of this camera like my own breath and, this morning, it's too slow. So I crank the knob up to sixty-four frames a second and it sounds like the usual twenty-four. I hope for the best and keep on filming. The lads are so jazzed to be moving again that I can't possibly ask them to slow down or wait while I set up a single shot. I pull the Bolex out of the surplus gas-mask pouch at my waist, grab another shot, put the camera away again, and jumar up the next pitch. Just keep filming.

The hidden geometry of our buttress fools us over and over. We ought to be there already, but a row of gendarmes says, "Not yet." Looks like we'll bivy on the way down, but today no one gives a shit. After two months farting around under a high-speed sky, worried about wind and storm, we tell ourselves the weather will hold forever . . . or at least till tomorrow. And it does.

And then there's the slow evening trudge up the final boulder-strewn, snow slopes to the top of the Fitz. Everyone humoring me, the movie guy, now that we are on top, but still hinting that I should hurry. We all hurry. And of course, we bivy on the way back down. (Dorworth and I will spend the winter teaching skiing at Squaw Valley, feeling our toes tingle from this night out in our frozen wet boots. But who cares?) Morning breaks cold and still clear.

And then time speeds up: We're out of there, pooling our Argentine currency for a seafood feast in the first restaurant we reach, flying back to the States on New Year's Eve, and crossing the midnight champagne line three times between Buenos Aires and California.

Now the story really gets complicated, starts to blur, shifts to the screen of my Zeiss Moviscop high above the San Francisco Bay, where my buddies keep kicking the same steps up the same wind-packed snow, back up, endlessly. We'd climbed our mountain, now I had to climb my film. But which film?

We had started out in pursuit of another *Endless Summer*, and I'd brought back a lot of footage, from thousands of miles of travel; it was miraculously well exposed, even the summit-day footage when I was worried that the camera was freezing. Beginner's luck, but still luck. So which film was I going to make? A road film? Perhaps. But that seemed a very tall order.

Better to start with Fitz Roy, start with a climbing film, not a feature—Fitz Roy by a new route, the third ascent. My first film and so much to learn. I dove in and started learning. Cutting shots together for continuity, stringing three or four scenes into one smooth motion, again and again, until it worked. Then learning that discontinuity and jump cuts are often more important than continuity, more important than just

As I worked to build film sequences that made sense, I wondered if it's ever possible to stitch a film together without taking liberties with the timing, with the real time line of real events. Back in Patagonia we went up on the mountain, then came back down to base, then went up again, again, and again, carrying loads, stocking our second ice cave with enough food to wait out long spells of bad weather. But in the film we go up, and there we are. Back in Patagonia we spent weeks hanging out in those ice caves. In the film, five minutes of ice-cave living seemed an eternity; it was an eternity on the mountain.

Films, I learned, compress time. Eventually a half hour of tightly edited mountain memories replaced sixty days on Fitz Roy, with a few minutes of blue-sky

"NOW THE STORY REALLY GETS COMPLICATED, STARTS TO BLUR, SHIFTS TO THE SCREEN OF MY ZEISS MOVISCOP HIGH ABOVE THE SAN FRANCISCO BAY, WHERE MY BUDDIES KEEP KICKING THE SAME STEPS UP THE SAME WIND-PACKED SNOW, BACK UP, ENDLESSLY."

replicating reality. Film questions reality, makes its own reality, even documentary film—especially documentary film. This was another adventure, another climb: memory confronting reality and ultimately winning. Climbing memories that inevitably tend to fade, blur, and lose themselves, redeemed in film memories-to-be.

I recorded a sound track by loosening up the lads with lots of red wine, one at a time, while the tape recorder kept turning. I collected revisionist memories, stories of our climb replacing the actual climb, remembered conversations replacing real ones. The sound track that emerged would have no narration, just a densely mixed collage of different voices, the voices of my Funhog buddies, telling their own stories in bits and pieces, but adding up—I hoped—to one coherent story of our climb.

footage standing in for our eight clear days on the mountain. Editing a documentary film, I found, frees one's own memory from a strict time line, sends it off on its own trip. The way it was, or wasn't. Following its own story.

Our climb had a real story, a good story, made of hard work, bad weather, frustration, temporary defeat, stubborn persistence, and a happy ending—a summit. The film I was putting together followed this story, not moment by moment, not in real time, but in film time—perhaps just as real, but definitely different. As summer drew on, I realized that my film was going to work. I learned not to explain too much. I didn't need to tell who was talking, who was answering. I improvised wind sounds from electronic music and learned to cut audiotape with a razor blade.

Then I heard about a film festival that seemed tailor-made for us, for the Funhogs and their film:

the Trento International Festival of Mountain and Exploration Films, held annually in autumn in the foothills of the Italian Dolomites. Trento was one more goal, if I could just finish the film in time.

I picked up the first "answer print" of my half-hour Fitz Roy film from the lab in San Francisco and jumped on a plane to Italy. The print wasn't perfect; a few shots were too dark, one stormy shot of the retreat from our ice cave had a weird green cast, and a couple of dissolves didn't work the way I'd hoped. But there was no more time. I had just barely managed to enter our Fitz Roy film in the Trento festival. *Andiamo!*

Fast-forward to cool autumn sunshine painting the medieval arcades around the main piazza in Trento, Italy. The festival was a weeklong, end-of-season party for climbers and filmmakers from all over Europe.

Sausalito, I was also assembling the film sequences I had shot of the whole trip south, from Ventura to Patagonia. There were some splendid moments: surfing in Central America, skiing a smoking volcano in southern Chile, driving through jungles and across deserts, all the crazy colors of a crazy continent. But I had reluctantly come to the conclusion that we didn't have the material for a strong feature film, and I didn't have the chops to make one. It turned out I was both right and wrong.

A few years later my indefatigable and ever-optimistic buddies, Yvon and Doug, who, after all, had financed the filming, commissioned some experienced movie pros to make a longer film, *Mountain of Storms*, about the entire Funhog trip, using the footage I'd shot and the sequences I had edited. Happily, that film too found its public, and told a good story, the Funhog

"OUR CLIMB HAD A REAL STORY, A GOOD STORY, MADE OF HARD WORK, BAD WEATHER, FRUSTRATION, TEMPORARY DEFEAT, STUBBORN PERSISTENCE, AND A HAPPY ENDING—A SUMMIT. THE FILM I WAS PUTTING TOGETHER FOLLOWED THIS STORY, NOT MOMENT BY MOMENT, NOT IN REAL TIME, BUT IN FILM TIME—PERHAPS JUST AS REAL, BUT DEFINITELY DIFFERENT."

There was a great film about Walter Bonatti. Jerzy Surdel from Poland presented his film, *Odwrót* ("The Retreat"), which I thought was the best mountain film I'd ever seen. What on earth was I doing here with my twenty-seven-minute Fitz Roy opus? The films went on for days. I felt out of my league and could only calm my nervousness with endless cups of strong Italian espresso. And then it was over. On the last evening, in the Cinema Dolomiti, *Fitz Roy: First Ascent of the Southwest Buttress* won the grand prize, the *Gran Premio Città di Trento*. Holy Moly! Almost as good as climbing the Fitz, I had finished my own climb. I was one happy Funhog.

What about our mad dream of producing another hit feature like *The Endless Summer*? While I polished my Fitz Roy film in that hillside editing studio in

story, in a very different way, with an omniscient narrator and a fair amount of rock and roll. Good stories—good memories, too—never lose anything in the retelling, even though they are devilishly hard to hang on to because they shift and change with time.

So it's true. You never climb the same mountain twice, not even in memory. But Fitz Roy is still our mountain. The film I made ends with Chris Jones pulling out his trusty Rollei 35 camera and taking a summit photo of our three mates—Yvon Chouinard, Dick Dorworth, and Doug Tompkins—holding the flag we had brought all the way from California with its simple message: Viva Los Funhogs. On the sound track Chris says it with perfect British understatement: "It was a good experience." And it's still true. I was there.

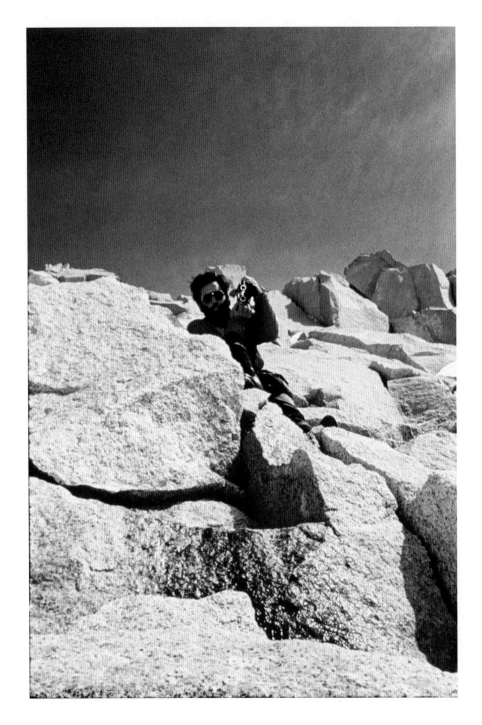

Cineaste Lito, now on sunny rocks towards the top of the buttress, films down the mountain. - CJ

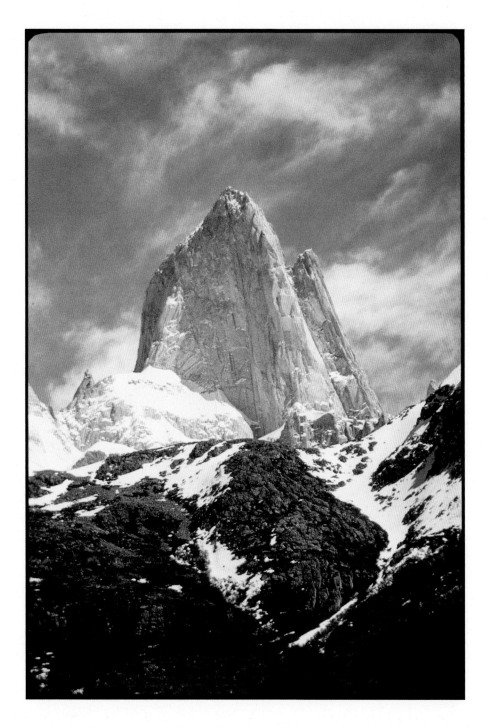

Fitz Roy as seen from our approach route. High clouds suggest that the wind is tearing past the peak. - CJ

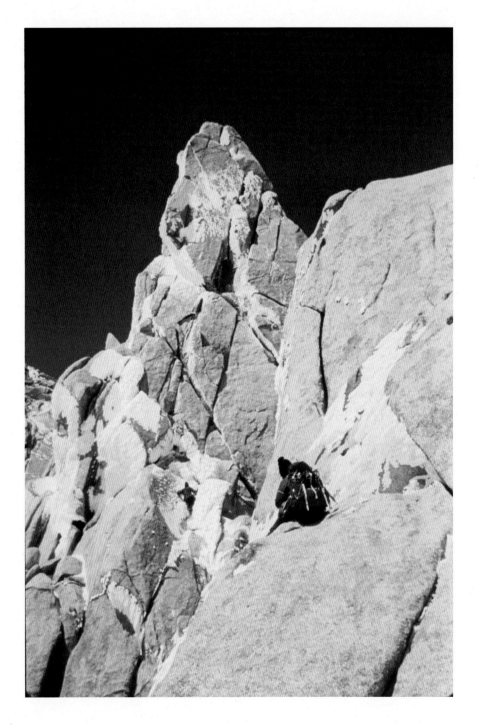

The series of pinnacles barring us from the summit. Here Doug leads, belayed by an unseen Yvon, while Lito films. - CJ

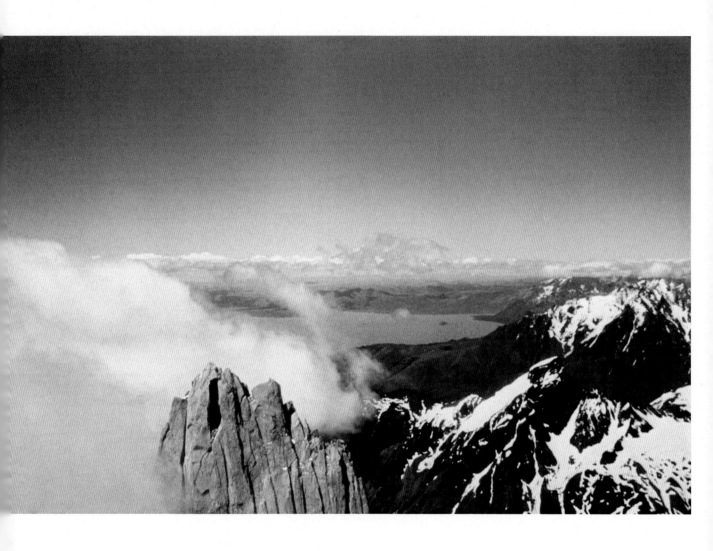

As we top out on the buttress, the summit of Poincenot now drops away below. In the background, Lago Viedma. - CJ

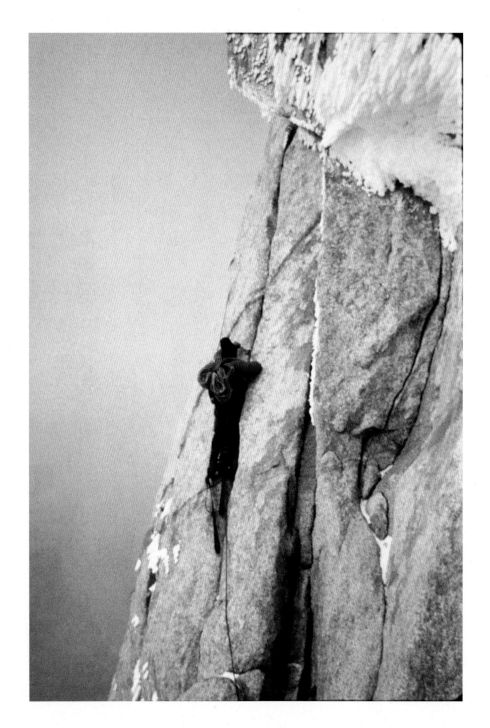

Doug cleaning a pitch on the ice-rime coated pinnacles. - CJ

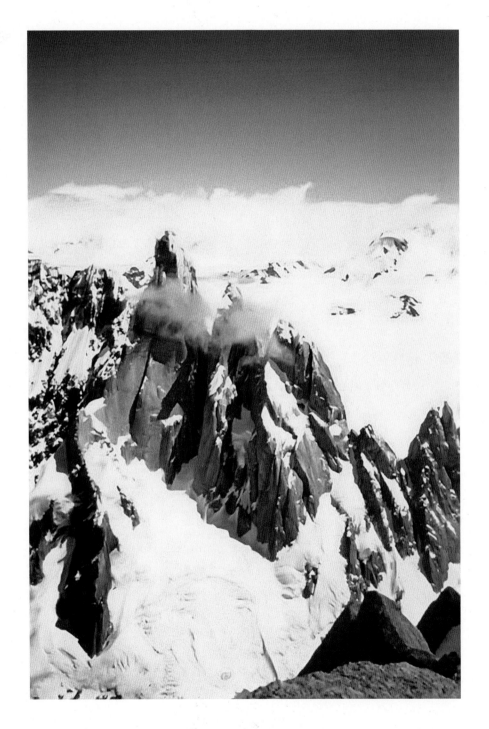

The formidable Cerro Torre, seen as we approach the easier ground leading to the summit. - CJ

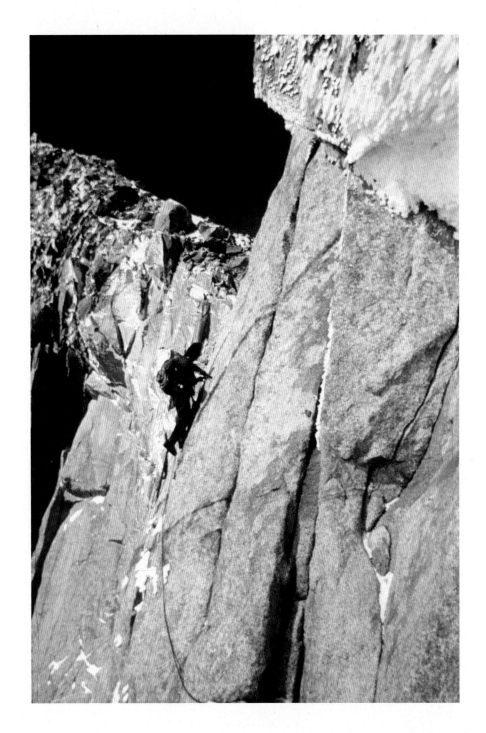

Doug higher up on the pitch he was cleaning; the mists have cleared, and the summit slopes are visible in the background. - CJ

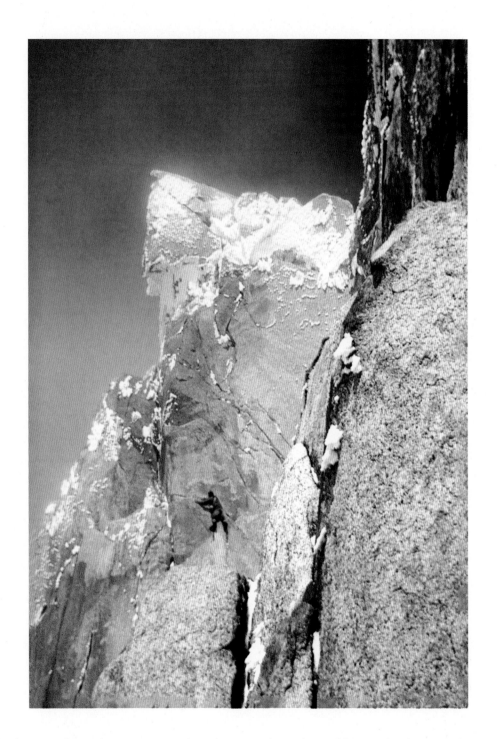

Yvon leads across a thin crack. Tense moments pass as the mists swirl around us, and the route ahead is not entirely obvious. - CJ

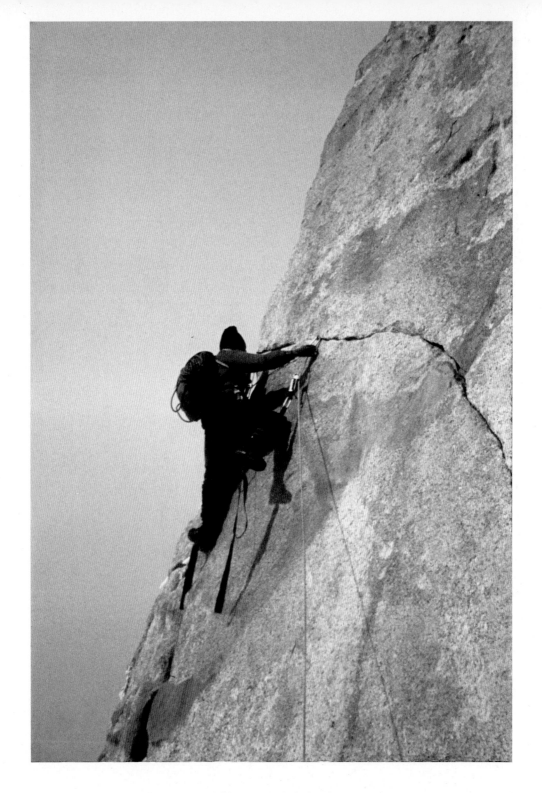

Doug, in aid slings, follows the thin left-leaning crack climbed by Yvon in the previous image. - CJ

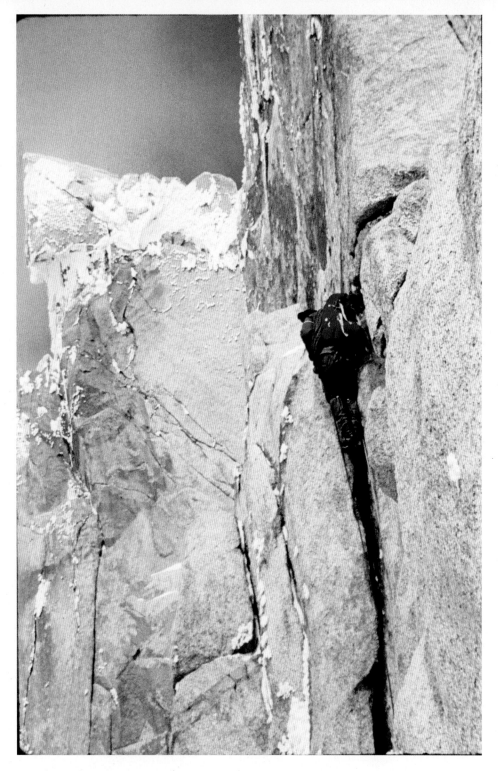

Lito jumars up the hardest pitch of the climb, an awkward vertical off-width climbed in mountain boots. Subsequently avoided by smarter parties. - YC

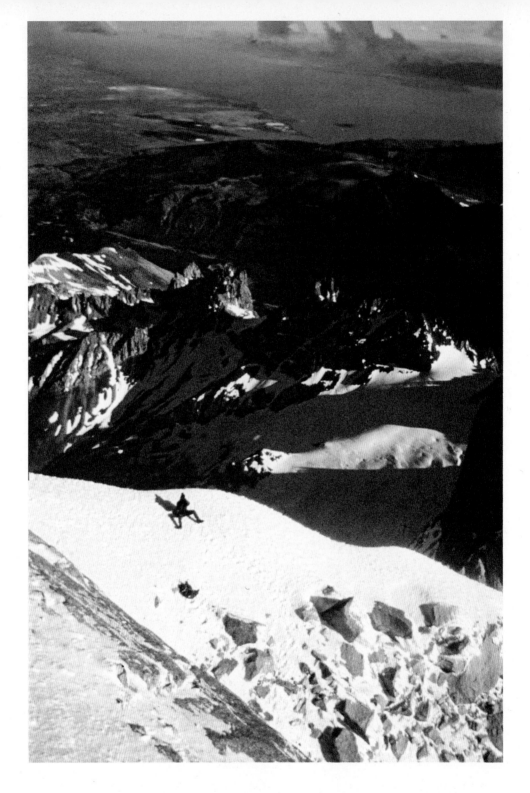

Lito sets up a shot of the team approaching the summit, and so stays behind momentarily. - CJ

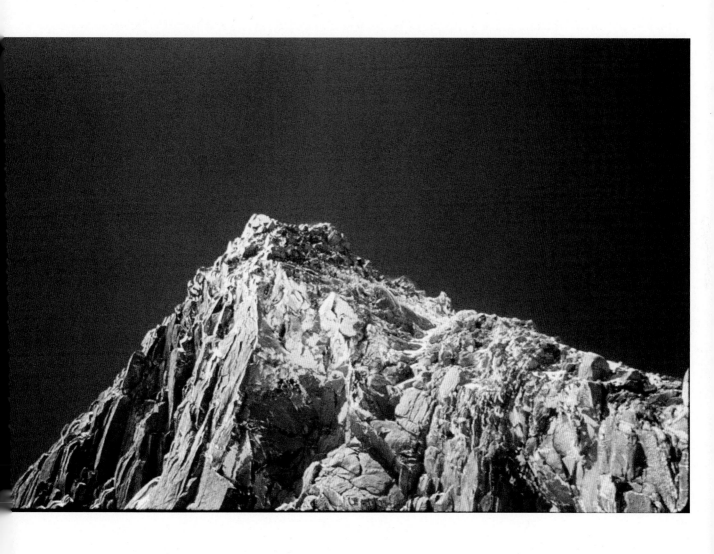

The moderate summit slopes. We need to hurry as the day is getting late. - CJ

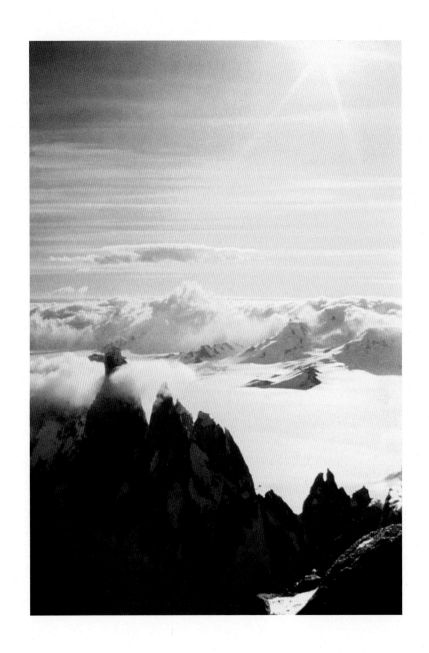

And the sun is getting lower in the sky! - CJ

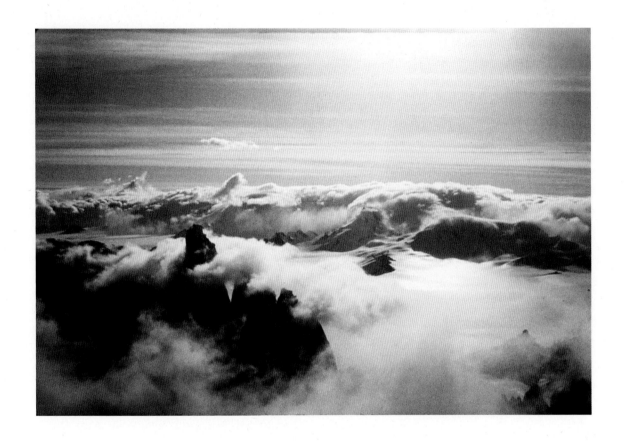

The almost unbelievable view of Cerro Torre and the ice cap. The weather is still holding, but looks a bit menacing. - CJ

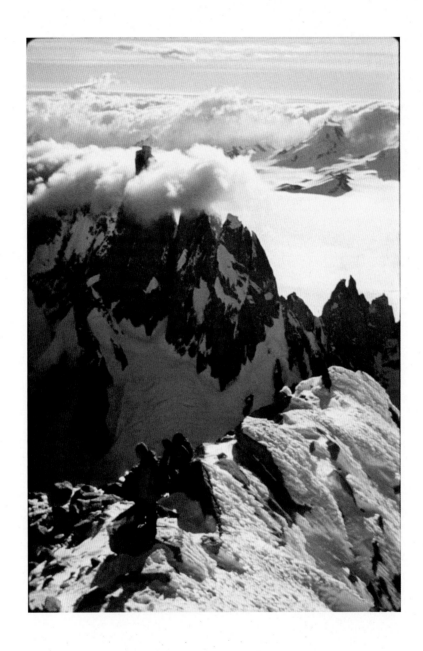

Looking back on the stunning Cerro Torre as Dick, in front, and Lito climb the now-straightforward summit ridge of Fitz Roy. - CJ

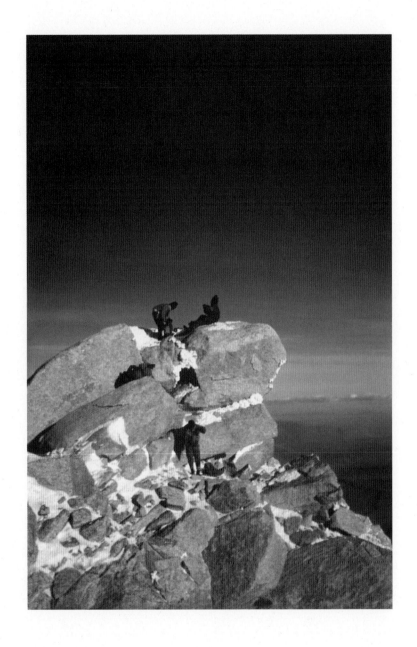

The summit! Lito, sitting at right, prepares to film. Yvon, at the base, prepares to climb up, while Doug, on top, looks into his pack. Dick, in red just below Doug, is partially obscured. - CJ

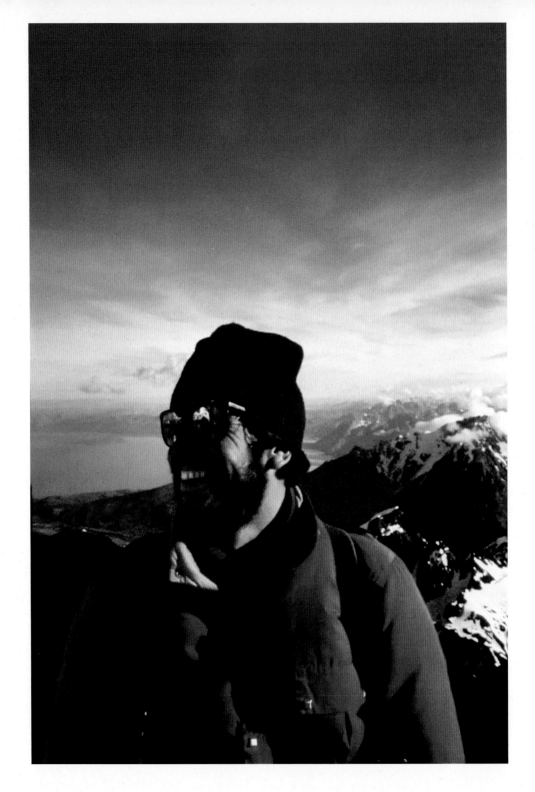

Doug is ecstatic on reaching the summit of Fitz Roy. Probably more than any other, he had spearheaded the climb. - CJ

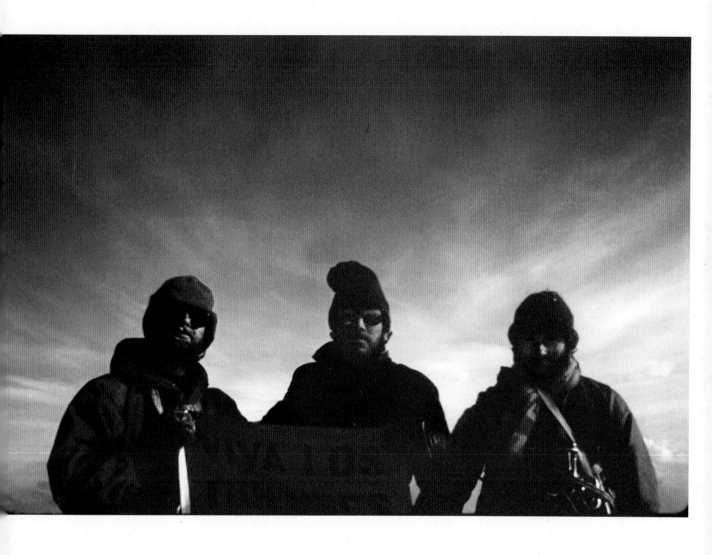

It is long way back to our ice cave! - CJ

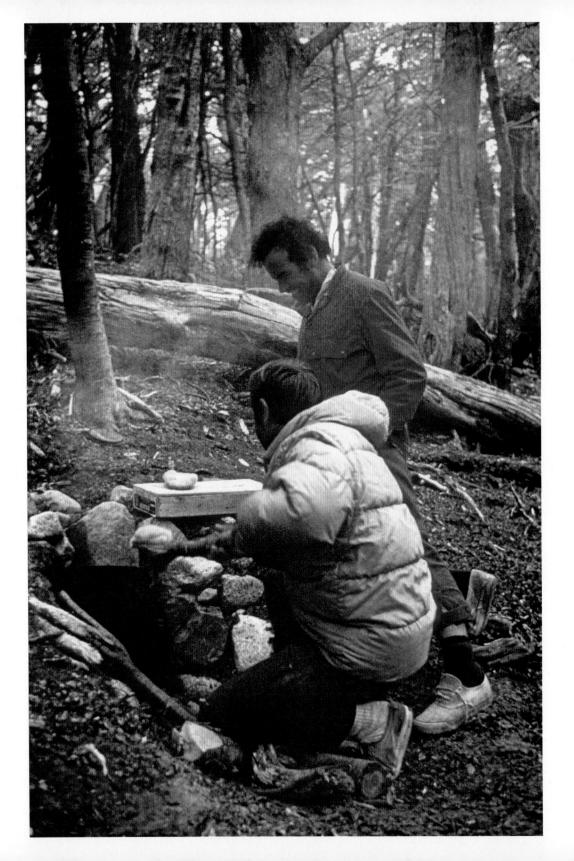

Adventures of the Irresponsible
Doug Tompkins

It challenges the mind to recall with accuracy—nearly forty-five years later—the now "legendary," 1968 Funhogs-go-to-Patagonia trip. So much legend has been woven into the tale, so many blurry edges of memory, so many recountings and embellishments of anecdotes, that the real story has evolved into a kind of epic adventure. Perhaps to recount what may have really happened would disappoint the reader.

This is, of course, disenchanting, like rain on a picnic, but surely we could not have been the swashbuckling adventurers we thought we were. We weren't Shackleton at the South Pole or Burton discovering the Nile. It was a long overland trek through Latin America in a beat-up van by five dirtbag climbers—with surfboards, skis, and climbing gear—avoiding proper and serious work, leaving their wives or girlfriends to fend for themselves, and searching for god knows what. It was, in short, a way to avoid coming to grips with entering the industrial work force, and a way to continue the long steady inflow of adrenaline and peak experience action that we had all become addicted to.

We were just another small group of mountain and ocean yahoos off for a long *On The Road*, Kerouac-type adventure, with all kinds of spurious excuses that this was what life was really about. I admit it, we were drunk on our own self-righteous justifications for doing something significant, when in truth it was really about skirting doing anything that had some social or environmental worth. We

did have one supportably righteous thing about us: We were all against the war in Vietnam.

So in the middle of 1968, I kissed my wife, Susie, and our young daughters goodbye and off I went with the lads. The first part of the trip went along the same lines as my earlier Mexican surfing trips as we surfed in familiar places until we finally pushed out of Mexico and hit new territory.

An episode that sticks in my mind occurred while camping in Guatemala. If I remember correctly, we were brought out of our dreams by the sound of automatic weapons being cocked in the predawn light. I opened one eye to see what was up, only to have my sleeping bag pulled up around my head, leaving only my eyes in the opening. A teenage soldier pointing his automatic rifle at us was shouting something in Spanish that wasn't at all clear to my rough understanding of Spanish in those days. I noticed the point of his gun shaking as he spoke. Then Lito, the best Spanish speaker among us—and the one given to speaking more than any of us anyway—sat up with his hands over his head, speaking at 90 mph.

According to the soldier in charge of this small unit, they had shot an infiltrator, a rebel of sorts, the night before and, though wounded, he had escaped. We were ordered to get out of our sleeping bags and show we had no wounds. Lito, still talking at 90 mph, explained we were merely sport-adventure tourists—our California license plate as evidence—just on a vacation to their wonderful country. If we saw

Opposite: Supplies are getting low and the one thing we crave above all else is bread. Hot bread with European canned butter! - YC

anyone suspicious we would report that to the police or to the army. It was over fairly quickly—they bought Lito's explanation and left us to gather our stuff and get back on the road.

On we went through Central America, mostly without incident, hitting good surf spots in Panama where we had heard there were good breaks, although the swell was moderate. We crossed the Caribbean by Spanish freighter, which proved a bit of an adventure in itself.

On through the winding roads of Colombia and down into the lowlands of Ecuador. We found more beaches and good surfing north of Guayaquil, with no other surfers and breaks that had perhaps never been surfed until then. After that we passed into northern Peru and surfed down the coast with various small adventures, as we met surfing friends and had close calls in big water, rocky shores and off surfing piers, even breaking a board in 15-foot waves. We did some sand-skiing with some Peruvian-thrillcraft types in dune buggies and had good meals and pisco sours for the drinkers among us. Finally, we pushed south into Chile.

One night along the north Chilean coast, we had parked on some high bluffs above the ocean; several of the lads were sleeping on the ground and I was on the sleeping platform in the van. With neither warning, nor provocation, the van slipped out of gear and began to roll forward towards the boys sleeping on the ground, and to the cliff and certain death. Instinctively, and by great luck, I managed to dive over the seat, plunged to the front floorboards, and put on the brakes with my hands, just managing to stop the van before it ran over the fellows and the cliff beyond. It did prove that the mind, even in sleep, can still be alert. In searching my memory that is how it seemed to have happened, although my fellow Funhogs might have even a totally different story !

On south to Santiago, where we did an on-the-street overhaul of our engine, which needed new pistons. Farther south, we skied down the Llaima Volcano near Temuco and put our arms in the smoke billowing out of the crater. Here Dick Dorworth, the best skier among us, showed his talents. We had a great time skiing and filming in the beauty of the Chilean Lake District: This was Araucaria country, characterized by the beautiful monkey-puzzle trees of south Chile.

At the end of the road in Puerto Montt, Chile, we crossed the lakes into Argentina and Bariloche, and spent some weeks rock climbing and got ready to launch ourselves into Patagonia for the last push south.

The trip from Bariloche was beautiful. We drove farther south through the rural towns of El Bolsón, with only horses tied to the hitching posts outside the bars, and Epuyén, and Esquel south of the beautiful Los Alerces National Park. Those were the days to have been there, even prior to the hippie invasion of the mid-1970s. (Although that invasion did exert a positive and greener influence on the region, finally putting pressure on mining, bad forestry, and even protesting the idea of a nuclear waste dump in Patagonia. Today's environmental movement in Argentina has many of its roots in this cultural shift.)

On we drove, feeling the very sparse population and the wide-open spaces reminiscent of some parts of the western United States, but without any pavement. Practically all we saw were sheep stations and the small towns where stores supplied the staples for the sheep *estancias* and provided some small social life for those living in the Patagonian outback. We traveled for days, with many flat tires, a million potholes, and 900-plus miles of washboard road. Then, from out on the steppe, we finally saw the Fitz Roy massif from a great distance. We stopped—that I remember well—and stretched our bodies and stared

out to the west, thinking that finally, there she was, the Fitz Roy, mythical peak of Patagonia, named by the equally mythical, Argentine equivalent of John Muir, Francisco "Perito" Moreno, for Robert FitzRoy, the captain of Charles Darwin's ship the *Beagle*.

Could we see the line we wanted to climb from there? We all debated it, but we knew very little of what we were going to find. I had only seen a few photos of the mountain and those were on the cover and in the book about Lionel Terray and Guido Magnone, the French alpinists who had led the first ascent. I had also seen some of the photos shot from the west side by Jose Luis Fonrouge and Carlos Comesaña, the Argentines who had done a new route up the Super Couloir in 1965. Fonrouge had been living at

lifetime, an entire town has materialized in that spot. It is scary to realize how rapidly civilization advances and the ugliness and the poor development that pour in to take advantage of the spectacular scenery in the background, while despoiling the foreground so brutally. Development is wildly out of control, hurtling culture towards a dystopian nightmare, one that we are more accustomed to in big cities, but that is more startling and unnerving in the once wild southern Patagonia.

The climb was remarkable for us. It was a time in climbing history that was much more innocent; we were not as fast as today's climbers, not as technically skilled either. Our minds were locked and restricted into the standards of the day, which set our boundaries only slightly ahead of what had already

"IT IS SCARY TO REALIZE HOW RAPIDLY CIVILIZATION ADVANCES AND THE UGLINESS AND THE POOR DEVELOPMENT THAT POUR IN TO TAKE ADVANTAGE OF THE SPECTACULAR SCENERY IN THE BACKGROUND, WHILE DESPOILING THE FOREGROUND SO BRUTALLY. DEVELOPMENT IS WILDLY OUT OF CONTROL, HURTLING CULTURE TOWARDS A DYSTOPIAN NIGHTMARE, ONE THAT WE ARE MORE ACCUSTOMED TO IN BIG CITIES, BUT THAT IS MORE STARTLING AND UNNERVING IN THE ONCE WILD SOUTHERN PATAGONIA."

our house in California for some months the year before, so we had talked extensively about climbing in Patagonia. The mountain was bigger than life in my imagination. And now we had seen it—although from far, far away—and we were getting psyched. The conversations back in the van were accelerating significantly as we continued on some sixty miles across the grassy steppe.

We arrived in the valley of the Río de las Vueltas. There were only a few sheep and no buildings whatsoever where the town of El Chaltén is located today—not one single structure! It is tough to accept that the implacable "March of Progress" has so altered a place as to be unrecognizable today, that you could be in a place without a structure and, in half a

been done. Speed and solo ascents were not the norm at that time, so we had no pretensions of any such thing. And we were trying to make a film of it all, to naively express ourselves and our values.

I look back at those times now, amazed by how naive and uninformed we were, yet I suppose that is how almost everyone sees their inexperienced youth. We were ambitious for our time, ready for anything and eager to put the cherry on the cake of this long and adventurous trip. We had at least reached the final goal and we were sure we would make a great climb of it.

I had no doubts that we would climb Fitz Roy, yet we had our work cut out for us; it would take us a long

time, much more than we had bargained for. We would become, as Terray had said, "conquistadors of the useless," an existential metaphor that appealed to me then, and perhaps even more now, with what little wisdom—or better sense of irony—that I may have accumulated over the years.

I will not go into the details of the climb and the trials and tribulations we had with the weather: the twenty or thirty days in a snow cave, the drowsy semi-sleep of day in and day out, the interminable hours waiting out storms, and the dreamtime story-telling to keep us semi-occupied as we wiled away the time waiting for better weather. We got on well for the most part, although expeditions in tight quarters often cause friction, and some of us were undoubtedly less patient than others. If, indeed, we

and set off down the mountain in the building wind. After what seemed like (and may well have been) an endless night with ropes blowing straight up, we stumbled into the ice cave, tired but delighted, congratulating each other on a marvelous adventure and the deed that we finally accomplished. Reaching the summit was the proper cap to the long trek from California and the thread of adventures along the way.

What took place in the subsequent days, I cannot really remember, although we had to do some filming for Lito to help him piece the film together coherently. After that we had ice cream on our minds, and probably within a week we were, in fact, eating ice cream on a street corner in Comodoro Rivadavia.

"I LOOK BACK AT THOSE TIMES NOW, AMAZED BY HOW NAIVE AND UNINFORMED WE WERE, YET I SUPPOSE THAT IS HOW ALMOST EVERYONE SEES THEIR INEXPERIENCED YOUTH. WE WERE AMBITIOUS FOR OUR TIME, READY FOR ANYTHING."

had grumbles, they disappeared as we pulled our last steps onto the summit and raised our little flag with broad smiles.

We were on the top of the world at that moment—masters, in our own minds, of all we surveyed. Suddenly all the agonies of the ice caves, the cold hands and feet, the discomfort and poor or little food, the uncertainty in the final weeks as to whether we would get enough good weather to do the climb, all vanished. The great weight of wondering if we would get to the top was off our shoulders. That surge of satisfaction all climbers feel when they have reached their goal was gushing from all five of us.

Now we turned our attention to what is often the most dangerous part of climbing, the descent, where the relaxation of one's vigil to be safe and prudent can lead to trouble. We reminded each other of this,

How does a major trip like this from California to Patagonia, when roads were far less developed than what they are today, in a secondhand van we bought cheap in San Francisco, shape one's personal trajectory in life? Many people have asked me this. It is hard to say. We should be careful not to make more of things than what they are. Yet, this was a formative experience, and now that the majority of my days are behind me, it seems fair to look back and see what it was that pointed me where I have actually been these last forty-five years.

Certainly, my now intimate connection with Argentina and Chile grew out of these experiences. In the early 1990s, Yvon and I, along with our good friend Rick Ridgeway, walked in to take a look at the most formidable face in the Patagonian Andes: the south face of San Lorenzo. That walk resulted in the conservation purchase of the *estancia* in the valley

leading up to the peak, and soon we will donate this property to enlarge the Perito Moreno National Park, which shares its boundary.

The years of skiing, kayaking and climbing, in both Chile and Argentina, left me with great experiences, great knowledge of the mountains and rivers, and a great group of friends in both countries. I became, after so many visits year in and year out, as familiar with the Southern Cone perhaps as anyone, especially south of the 40th parallel. Now, as the years pass and with four round-trips in a single-engine plane back and forth from California to Patagonia (some down as far as Cape Horn), I am certainly settled in my life in the Southern Cone.

Finally, in 1990, I moved permanently to Chile and became seriously involved in land conservation. Best of all though, it was my good fortune to have met back up with Kris McDivitt, a friend and business partner of Yvon and Malinda Chouinard, when Kris came down to southern Argentina for a Patagonia company meeting. As all good romance novels go, we fell in love, got married, and have been living happily ever after, working on environmental and conservation projects now for over twenty years in Chile and Argentina. All of that has been, in some ways, the mark of my destiny when we got in that van in 1968. I would be fooling myself to say that that fateful adventure did not influence—and influence heavily—the direction life took me in.

So, I give thanks, as I look back, that fate played its mysterious hand guiding me along a wonderful path, in a life with never a single moment of regret. If I could play it over, I would let it go just as it has, with all the minor bumps that came with it. Just like those bumps along the last 900 miles from Bariloche to the Fitz Roy valley—sometimes a bit uncomfortable, but still very enjoyable all the way.

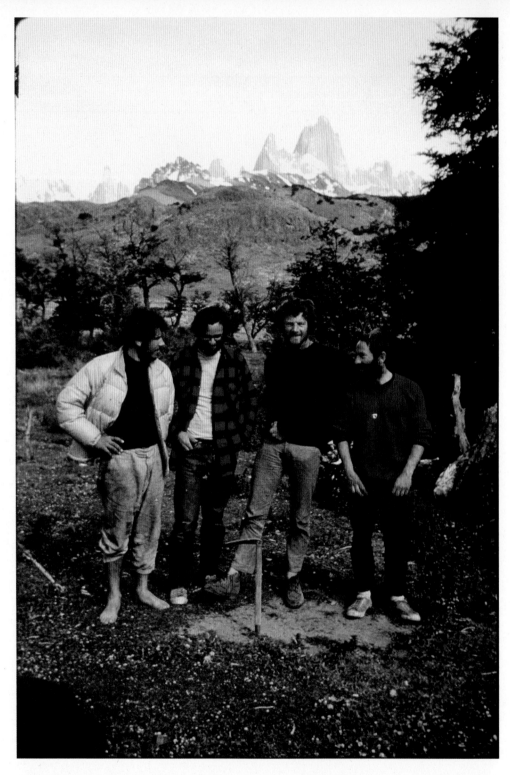

Doug, Dick, Chris, and Yvon (from left), disheveled but ecstatic, after changing into semi-respectable clothes. The ice axe adds an air of authority! - CJ

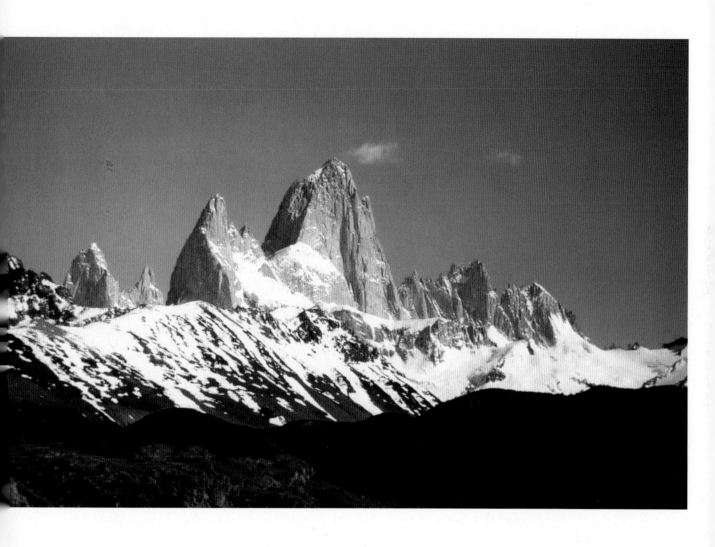

Cerro Torre (left) and the Fitz Roy group. - CJ

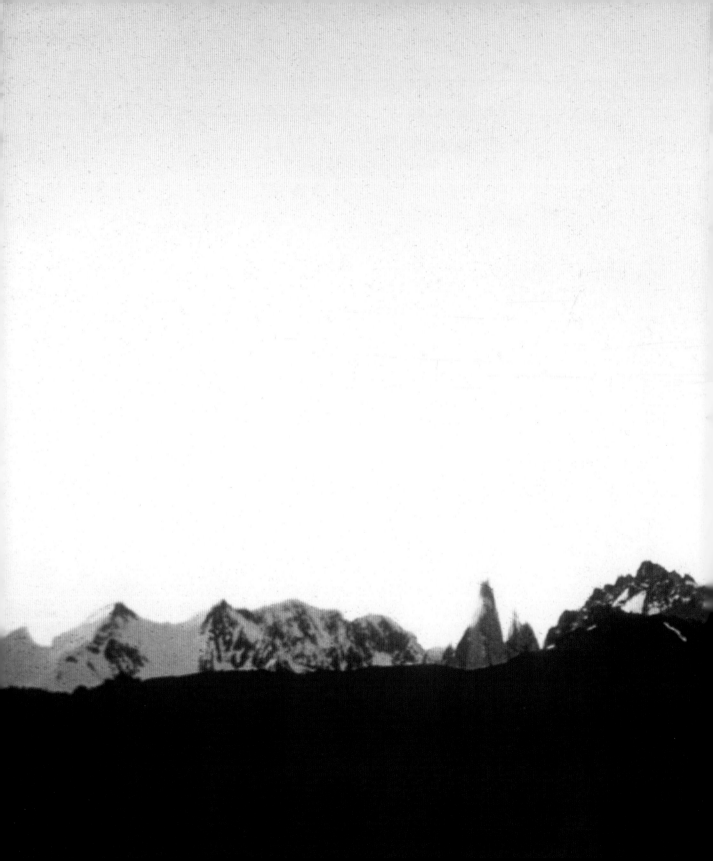

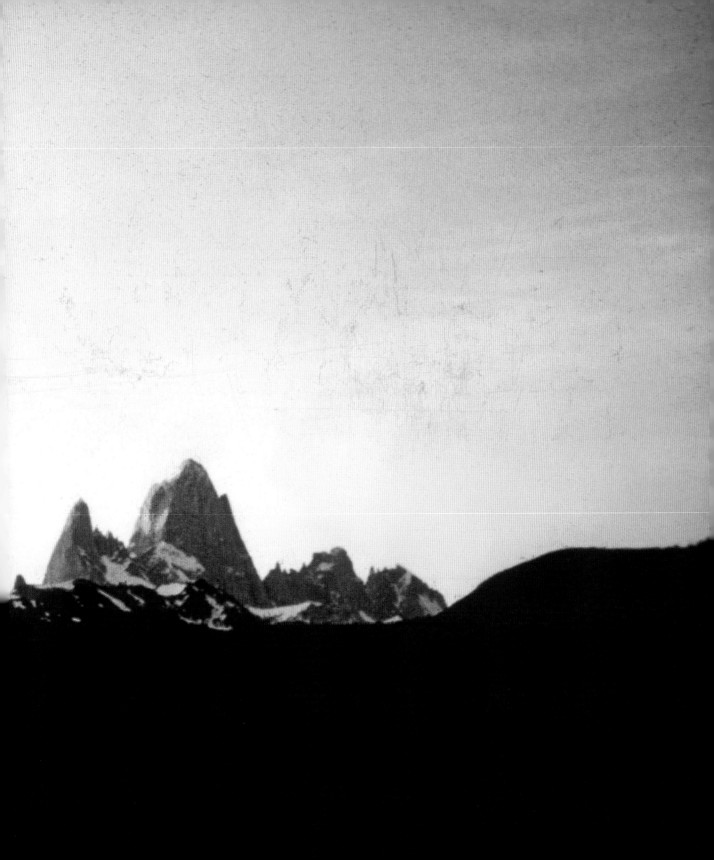

Previous: The crew, near the park entrance. – CJ
Cerro Torre (left) and the Fitz Roy group. - CJ

Contributors

Yvon Chouinard, a noted alpinist and environmentalist, is the founder and owner of Patagonia, Inc., which Fortune has called "the coolest company on the planet." He is also the co-founder, with Craig Mathews, of 1% For The Planet and the author of *Let My People Go Surfing* and coauthor of *The Responsible Company.*

Dick Dorworth was passionate about ski racing in his youth and set a number of records that stand to this day. His path crossed with several notable climbers and he was sucked into the world of mountain climbing which he pursued with equal passion. He has written numerous ski articles, and authored three books, *Night Driving, The Perfect Turn* and *The Straight Course.*

Chris Jones moved to the US in 1965 to work for IBM and then quit in 1967, moved to Yosemite and started to climb full time. Chris has climbed in the British Isles, Europe, the United States, Canada, South America, and Asia. Chris's book, *Climbing in North America*, was published in 1975 and received wide acclaim, and is widely regarded among the most influential climbing books.

Doug Tompkins is a mountain climber, deep ecologist, and forward-thinking businessman. Tompkins was the founder of The North Face and co-owner of the ESPRIT clothing company. With his wife, Kris, he is currently working to conserve large wilderness areas in Chile and Argentina.

Lito Tejada-Flores was born at 13,000 feet in the mountains of Bolivia. Since then he has had an affinity for high places. While primarily a filmmaker, his credits include a three-part technical skiing education series *Breakthrough on Skis*, which is also a book by the same name. He has also authored numerous articles and books on topics ranging from skiing to whitewater kayaking.

Climbing Fitz Roy, 1968
Reflections on the Lost Photos of the Third Ascent

Patagonia Books, an imprint of Patagonia, Inc., publishes a select number of titles on wilderness, wildlife, and outdoor sports that inspire and restore a connection to the natural world.

Copyright © 2013 Patagonia Books
Text © Yvon Chouinard, Dick Dorworth, Chris Jones,
Lito Tejada-Flores, and Doug Tompkins
Photos © Chris Jones

"Fitz Roy, 1968" by Doug Tompkins reprinted from the 1969 *American Alpine Journal* by permission of the American Alpine Club.

All rights reserved.
No part of this book may be used or reproduced in any manner whatsoever without written permission from the publisher and copyright holders.

Requests should be mailed to Patagonia Books, Patagonia, Inc.,
259 W. Santa Clara St., Ventura, CA 93001-2717
www.patagonia.com/books

First Edition
Photo Editor: Jane Sievert
Editor: John Dutton
Interior and Cover Design: Monkey C Media, www.monkeycmedia.com
Printed in China on 100% recycled paper

Chouinard, Yvon, 1938-
 Climbing Fitz Roy 1968 : reflections on the lost photos of the third ascent / Yvon Chouinard, Dick Dorworth, Chris Jones, Lito Tejada-Flores, and Doug Tompkins. -- 1st ed. -- Ventura, CA : Patagonia Books, 2013.
 p. ; cm.
 ISBN: 978-1-938340-16-1 ; 978-1-938340-18-5 (ebook)
 1. Fitz Roy, Mount (Argentina). 2. Mountaineering--Argentina. 3. Mountaineering expeditions--Argentina. 4. Mountains--Difficulty of ascent. I. Dorworth, Dick. II. Jones, Chris, 1939- III. Tejada-Flores, Lito. IV. Tompkins, Douglas. V. Title.

GV199.44.A72 C55 2013 2013910494
796.522092--dc23 1309